POSTCARD HISTORY SERIES

Ridgefield
1900–1950

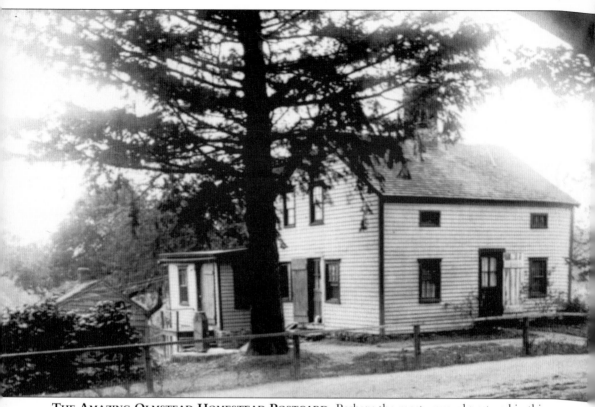

THE AMAZING OLMSTEAD HOMESTEAD POSTCARD. Perhaps the most unusual postcard in this book is this real-photo shot. First off, postcards of modest houses are uncommon; fancy places usually grabbed the postcard maker's attention. Although anyone could have limited-edition, real-photo cards done for their own use, most folks with modest houses like this could not afford the expense. What is amazing about this card, however, is that through many years and over many miles, it has returned to the house from which it was mailed nearly a century earlier—*my house*. Back *c.* 1910, widow Lizzie Olmstead, who lived in this house on Olmstead Lane, sent the card to a friend, writing a long note on the back and placing it in an envelope. Thus, it had no postmark and the only hint of its place of origin was this sentence: "Hope to see you in Ridgefield," included in the message. By the 1990s, a postcard dealer in Michigan had acquired the card and guessed Ridgefield was in Connecticut. In 1998, she happened to run across my name on the Internet as being a postcard collector and sent photocopies of two dozen Ridgefield cards she had for sale. Among them was this. As I scanned through the images, my eyes widened when I saw it. I had never had the remotest hope of finding a card showing my own house; yet here it was—and a beautiful, crisp, clear picture to boot. (To show my delight, I gave the seller more than twice the price she asked.) The main part of the house, painted red today, is essentially unchanged, except for a porch added to the left side. Until I saw this card, I had not realized there was once a building with a chimney out back, apparently torn down long ago. Notice the cat in the side doorway.

POSTCARD HISTORY SERIES

Ridgefield
1900–1950

Jack Sanders

ARCADIA

Copyright © 2003 by Jack Sanders.
ISBN 0-7385-1172-2

First printed in 2003.

Published by Arcadia Publishing,
an imprint of Tempus Publishing Inc.
2A Cumberland Street
Charleston, SC 29401

Printed in Great Britain.

Library of Congress Catalog Card Number: 2002116956

For all general information, contact Arcadia Publishing:
Telephone 843-853-2070
Fax 843-853-0044
E-mail sales@arcadiapublishing.com

For customer service and orders:
Toll-free 1-888-313-2665

Visit us on the Internet at www.arcadiapublishing.com.

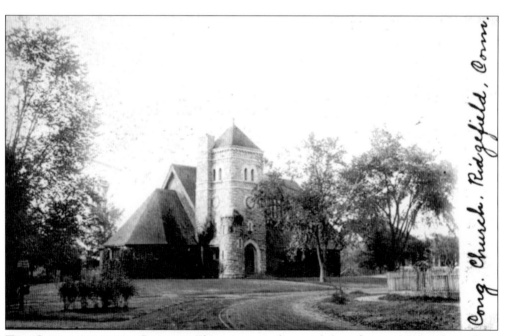

THE CONGREGATIONAL CHURCH. This private mailing card dates from *c.* 1900 and may have been the first picture postcard of Ridgefield. The view looks from Main Street south toward West Lane long before there was a fountain in the triangle at the left. The fence at the right belonged to the Corner Store, which operated from the early 1800s until 1929 (see page 12).

CONTENTS

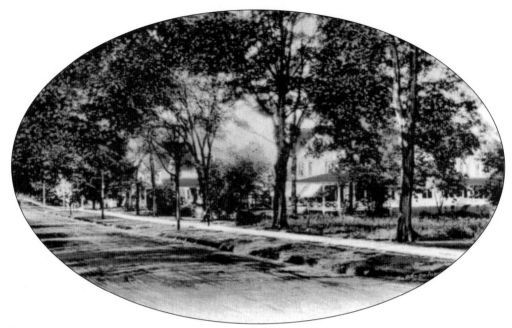

THE ELMS. Most picture postcards of Ridgefield bore rectangular images, but this hand-colored view of the Elms Inn complex is ovoid. Albertype published this early card, postmarked 1917, for pharmacist George A. Mignerey. For more views of the Elms, see pages 17 and 67.

Acknowledgments

The late Karl S. Nash inspired my interest in Ridgefield history, and Town Historian Richard E. Venus helped keep it alive. I am particularly indebted to both men for the history they recorded in the pages of the *Ridgefield Press*—Karl, as the newspaper's editor and publisher, who loved town history, and Dick as the author of the incredible "Dick's Dispatch" series of reminiscences of early-20th-century Ridgefield. Silvio Bedini, Ridgefield's greatest historian, also helped inspire my interest in community history, writing *Ridgefield in Review* and then moving to the Smithsonian Institution, where he produced nearly two dozen masterful books of history and gained an international reputation. He has also helped me gather information over the years. Charles Coles, Ridgefield's first and foremost collector, led me to the world of postcards. Among those who contributed to my collection were Laurie and Virginia Bepler, who have produced two books in this Arcadia series: *Route 7, the Road North: Norwalk to Canaan* and *Wilton in the Golden Age of Postcards;* Kay Ables of the Ridgefield Archives Committee, which authored *Images of America: Ridgefield;* and Carol Schilling, my sister-in-law. The archives committee also provided financial support that helped with the collection, which will eventually be donated to the Ridgefield Historical Society. Carol Ancona loaned two rare views of Branchville. Members of the Connecticut Postcard Club gave me much information and assistance. Finally, my wife, Sally, offered support in many ways—including accompanying me on some of the many expeditions to postcard and ephemera shows. To all, my thanks.

INTRODUCTION

"Ridgefield's face is her fortune," someone once wrote. While preserving that face has been the task of zoning, conservation, and historical officials, picturing it was largely the job of postcard publishers, whose hundreds of color and black-and-white images have recorded Ridgefield since the beginning of the 20th century.

Although the town's population was only 2,600 in 1900 and 4,400 by 1950, more than 500 different postcard views of Ridgefield were commercially published in the first 50 years of the 20th century. Much of this period was the golden age of the postcard, and much was also a golden age in the economy of the town. Ridgefield was also a popular destination for tourists seeking a picturesque country village or for wealthy New Yorkers looking for a weekend and summer retreat from the noise and bustle of the city. Postcards were ideal ways for both tourists and residents to show off where they visited or where they lived.

Picture postcards debuted in 1898, when Congress passed the Private Mailing Card Act. Before that, only plain, government-printed postcards could be mailed. With the 1898 act, private publishing companies could print pictures on cards and sell them. Purchasers could write a note, add a penny stamp, and pop the card in the mail.

"Private mailing cards" caught on quickly. When full-color cards were introduced a few years later, postcards became an incredible craze—millions were mailed each day.

Postcards were not only pretty but also a form of communication. Most people did not have telephones in the early part of the century. Long before people said, "Give me a call," they would say, "Drop me a line." The U.S. mail was the easiest way to keep in touch with family and friends who lived more than a few miles from your house. The postcard became an inexpensive and entertaining way to "drop a line." Also, it was fast; the message could travel hundreds of miles in a day—a card on page 37 went from Ridgefield to Ann Arbor, Michigan, in 23 hours.

The earliest cards, up to *c.* 1904, bore black-and-white images, often poorly printed. The picture of the First Congregational Church on page 4 may have been Ridgefield's first such card. Then, *c.* 1905, Americans discovered German lithography. Excellent German presses could inexpensively produce high-quality color picture postcards.

When World War I broke out, the source of good color cards disappeared. Americans turned to a different technique that, while less high-tech, produced beautiful cards. Black-and-white images were finely printed and then colored by hand, following instructions from the photographer. The chief producer of hand-colored cards was Albertype, whose Brooklyn, New York factory employed hundreds of people—probably many of them starving artists—to watercolor their images. Millions of hand-colored Albertype cards were published between 1915 and 1940. More than 150 different scenes were of Ridgefield.

Less-expensive, black-and-white cards were also being sold. The quality of these varied—some were quite good, and others looked like old newspaper pictures. Among the black-and-whites, however, were real-photo postcards, which were literally mailable photographs. Local photographers could produce these for anyone, and as a result, many limited-edition cards were

created. Few survive or can be identified since most real-photo cards by local photographers had no printed identification. However, Underwood & Underwood, a New York City company famous for its stereograph images, mass-produced several dozen different real-photo images of Ridgefield *c.* 1910; all came with printed identifications.

Local merchants commissioned most postcards as items to sell in their stores. Obviously they wanted views that people would buy. Thus, these pictures had to show interesting scenes and popular places. They had to reflect what was best about the face of Ridgefield. Views in the center of town, estates, inns, and churches were among the most popular sellers. They depicted what Ridgefielders wanted to show off about themselves and what visitors would find appropriate to reflect the town they visited.

Consequently, you will not see ordinary houses and you will not find farms, workshops, or people at work in the vast majority of old postcards. In fact, you rarely find people at all in postcards of Ridgefield—except as distant, unrecognizable individuals who happened to be in the scene when the photographer shot it.

Three pharmacies, all on Main Street in the village, accounted for almost all of the cards commissioned before 1940. The major local outlet was H.P. Bissell, which used half a dozen different publishers to print its cards, beginning *c.* 1910. George A. Mignerey and the Smith family, also Main Street pharmacists, sold scores of additional cards. A few postcards were commissioned by Finch's Cigar Store and Ridgefield Hardware, as well as by several of the inns, such as Outpost. In Branchville, Mead's store produced several views, most of them rare today.

In selecting cards for this book, I wanted the views that would reproduce well. After that, I looked for pictures that best demonstrated how Ridgefield has changed—and how it *has not* changed—in the past century. Many images show what architectural historian Madeleine Corbin calls "Lost Ridgefield"—beautiful buildings that were destroyed by fire or by the changing times. Dozens of mansions were razed in the 1940s and 1950s because they were simply too expensive to maintain. Others succumbed to flames. Some were simply torn down to make way for housing developments.

Many postcards show buildings for which there are no other known surviving photographs. That is both because postcards were more likely to be preserved by collectors and because most postcards bear printed identifications. Countless old photographs of people and places have become meaningless today because no one thought to write identification on the back.

Although many images show what has since disappeared, many others demonstrate how well 21st-century Ridgefield has maintained its 19th-century appearance. This is especially true of Main Street and High Ridge, both now in historic districts.

One

THE FACE OF MAIN STREET

"There is no fairer scene in fair Connecticut than Ridgefield's Main Street," a magazine said in 1908, likening it to "some lovely old-world park rather than a thoroughfare."

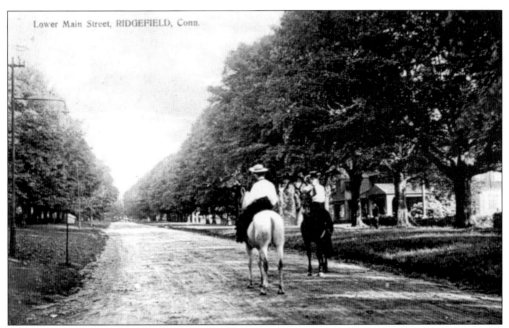

Lower Main Street, RIDGEFIELD, Conn.

LOWER MAIN STREET. It may seem strange to begin a book with the rear of a horse, but this wonderful card from *c.* 1910 is one of the more unusual and interesting pictures of Main Street. The card is among the few that prominently feature people—or horses. The view looks northward from the very south end of the street. The two young women, riding sidesaddle, may have been staying at the Ridgefield Inn, visible at the right. If you look closely, you will see, right in front of the inn, a man who appears to be in a uniform; he may have been the doorman for the inn or a family chauffeur watching the women to make sure they were safe.

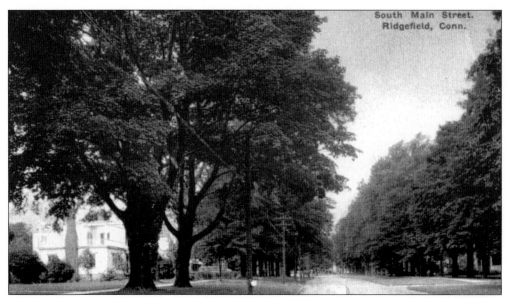

SOUTH MAIN STREET. This view looks northward from south of Rockwell Road. In her message on the back, "Lizzie" writes Mrs. Frank Baron of Providence, Rhode Island, "I told you that the streets of this town are all grass, but I don't let the grass grow under my feet. And the only thrill that I get is from the bugs in the woods, and can count all the people that goes [sic] by—about six a day." Lizzie lived on West Mountain, back then considered wild country.

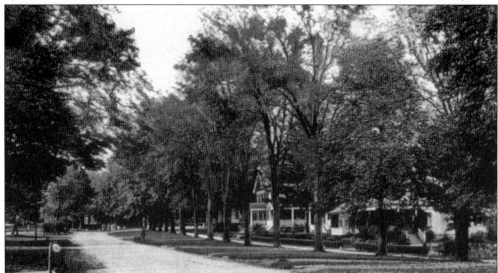

THE RESIDENCES OF DR. CADY AND THE MISSES CUSHMAN. This scene looking northward on Main Street was shot about where Rockwell Road intersects. The houses, barely visible through the trees, still stand today. In the distance is the old Corner Store, at the intersection of West Lane. Dr. Philander Cady, whose house is the more visible of the two, was an Episcopal minister and professor, whose architect brother, J. Cleveland Cady, designed the First Congregational Church right across the street (see pages 81 and 82). This card served as a Christmas greeting to Rev. L.M. Keeler of Danbury, from his sister, Sarah. Included in the message was this passage: "Anna is expected home this afternoon, but I fear she is not cured. She has been in the hospital more than two months." Merry Christmas, Reverend Keeler!

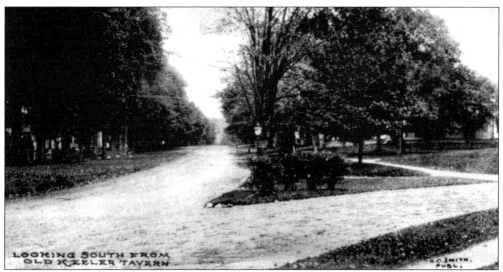

LOOKING SOUTHWARD FROM THE OLD KEELER TAVERN. The triangle at Main Street and West Lane, which runs off to the right, is shown, probably *c.* 1900—about 15 years before the fountain (below) was installed. Each night, the village watchman, hired by the Village Improvement Society for $1.30 a month, lighted the oil-lamp light that stood in the triangle and about 20 other lamps along Main Street. Beyond the lamp is a sign directing people to Wilton to the south or New York State towns to the west. This is a very early Albertype, hand-colored card; uncolored versions were also sold.

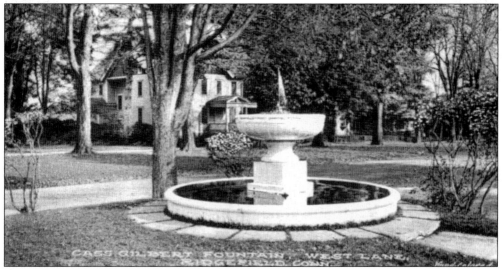

CASS GILBERT FOUNTAIN, WEST LANE. No symbol of Ridgefield is more remembered by more people than the fountain. Cass Gilbert was a noted architect who designed the U.S. Supreme Court building in Washington, the Woolworth Building in New York, the U.S. Customs House in New York, and several state capitols and college campuses; he was also involved in designing the George Washington Bridge. In 1907, he bought the old Keeler Tavern on Main Street (see pages 65 and 66) as his country home and, *c.* 1915, donated this fountain, which he himself designed. Over the years the fountain has survived many attacks by errant automobiles and today is raised a couple of feet off the ground in an effort to protect it. This hand-colored Albertype card, and another much like it, were among the best-selling Ridgefield postcards.

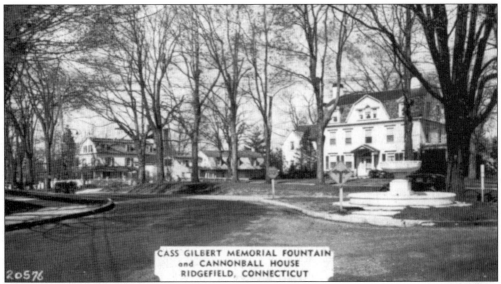

CASS GILBERT MEMORIAL FOUNTAIN
and CANNONBALL HOUSE
RIDGEFIELD, CONNECTICUT

20576

CASS GILBERT MEMORIAL FOUNTAIN AND THE CANNONBALL HOUSE. This postcard, mailed in 1941, shows both the fountain and Cass Gilbert's home, the Cannonball House, or Keeler Tavern, in the background at the far left. The card's title is technically incorrect: Cass Gilbert was alive and well when he designed and donated the fountain, which he considered an effort at beautification rather than a memorial. The card's publisher was Finch's Cigar Store, which became Squash's News Store when Aldo "Squash" Travaglini took over, and is now Squash's Ridgefield Office Supply, on Main Street.

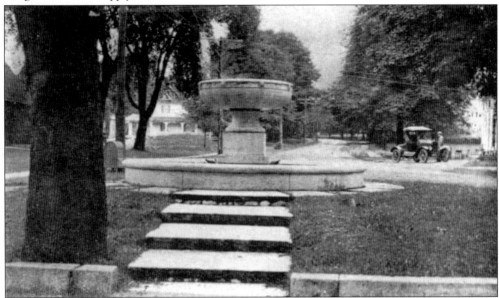

CASS GILBERT FOUNTAIN. Most postcards bear pictures taken from eye level. The photographer who shot this rare view was only two feet or so off the ground. The view looks to the west, right down West Lane. The car is parked in front of the Corner Store, and a sign partly visible says the store sold antiques. For most of its history, however, the establishment was a country store, carrying practical goods rather than tourist fare. This card, mailed in 1931, predates 1929—the year the store was torn down, leaving an empty lot.

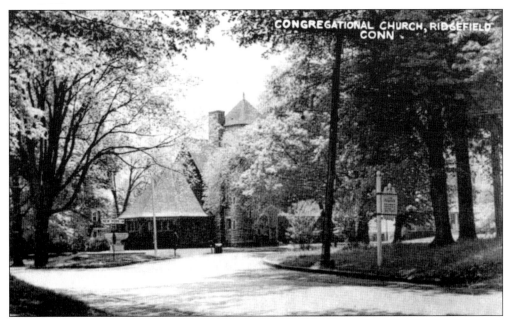

THE CONGREGATIONAL CHURCH. This beautiful view of the intersection of Main Street and West Lane is probably from the early 1940s. The handsome signpost at center right, directing travelers to places west or south, remained standing until *c.* 1990, when it was taken down for a highway project and never replaced.

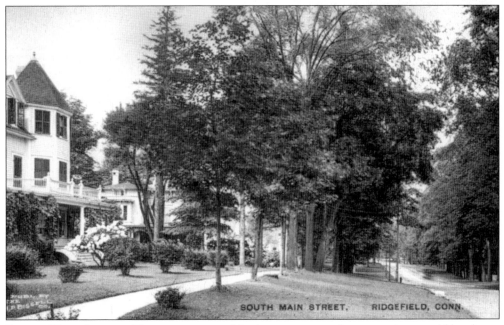

SOUTH MAIN STREET. If you were to stand in the same spot today, your view would be almost exactly the same as this hand-colored Albertype card, except the trees are bigger, the shrubs are different, and Main Street is now paved. The scene looks northward from the corner of Main Street and West Lane *c.* 1920.

THE RESIDENCE OF A.H. STORER. Albert H. Storer (1858–1932) was publisher of a New York newspaper. He retired and moved to Ridgefield, where he became active, serving as a St. Stephen's warden, library director, school board member, and borough warden. His wife, Sophie Storer, was a founder of the Ridgefield Garden Club. His house is barely visible in this view that looks southward toward the fountain from in front of the house shown below.

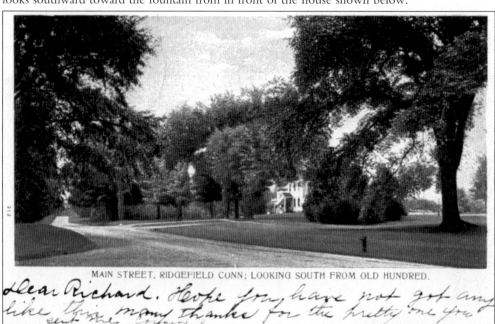

MAIN STREET, RIDGEFIELD CONN; LOOKING SOUTH FROM OLD HUNDRED.

MAIN STREET, LOOKING SOUTHWARD. This card, postmarked 1905, is an early German color print, based on a photograph used on even earlier postcards. An uncommon example of mislabeling, the card incorrectly says, "looking south from Old Hundred." Old Hundred is what is now the Aldrich Museum, much farther north; clearly, this is looking southward from Branchville Road. The card was printed during a period when the postal service did not allow anything written on the back of postcards except the address; messages had to be on the front. This note is interesting in that it reflects the collecting craze going on at the time: "Dear Richard. Hope you have not got any like this. Many thanks for the pretty one you sent me. Cousin R."

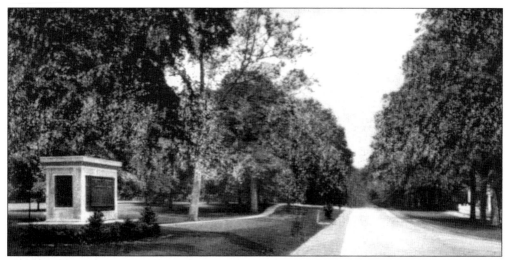

WARS MEMORIAL AND MAIN STREET. The monument at the left, usually labeled Wars Memorial on cards but today invariably called the War Memorial, was installed in 1924–1925 and bears the names of Ridgefielders who fought in the Revolution, the War of 1812, the Civil War, the Spanish-American War, the Mexican War, and World War I. This card demonstrates a technique common among postcard publishers: the touch-up. Smack in the middle of the original picture was a utility pole, with its accompanying wires. All have been artistically removed from the negative. In the grass in the middle, you can just see a dark, scratchy blotch that was the exorcized pole. In the image below, no effort was made to remove the poles, but they are not as ugly as they would have been in this picture. The image is probably from *c.* 1926 or 1927, just after Main Street was paved in white concrete.

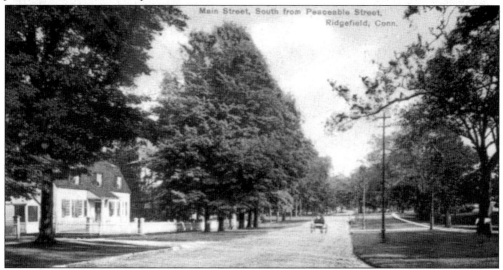

"MAIN STREET SOUTH FROM PEACEABLE STREET." This charming view, with the Hauley house at the left, is not much different from the one of today. Replace the horse and carriage with a car, add pavement, and stick more wires on the utility poles, and you have entered the 21st century. The German litho card, postmarked 1911, includes a message: "Peaceable Street is a very grand place, what?" It is possible that the writer thought Main Street was Peaceable Street. Actually, the view should properly be titled "Main Street South from King Lane," because Peaceable Street began one block to the west.

15

MAIN STREET, LOOKING NORTHWARD FROM OLD HUNDRED. If the photographer of the previous image had turned his camera northward, this is about what he would have seen. This picture is probably a bit earlier, however, maybe *c.* 1900. Old Hundred, now the Aldrich Museum, would have been just off the right edge of the picture. Although it is mentioned in the titles of several cards, there do not seem to be any cards that picture Old Hundred. Part of the fenced lot is now the site of the First Church of Christ, Scientist, built in 1965.

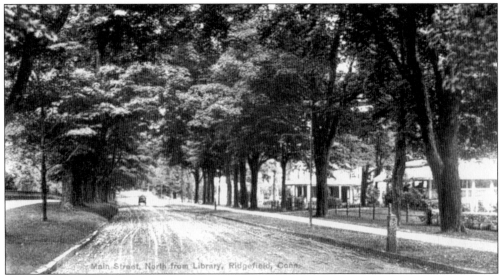

MAIN STREET, LOOKING NORTHWARD FROM THE LIBRARY. This view is farther north on Main Street, beyond the two blocks of the business center, which are covered in the next chapter. The photographer here was in the street in front of the library—the stone wall at right is on the library property. The house with the awning-covered porch belonged to a couple of different doctors and their families—the last was Dr. James Sheehan, a pediatrician here for a half-century. The place was torn down in 1984 to make way for the library expansion. Just beyond it are the Nash Apartments, still standing and still in business.

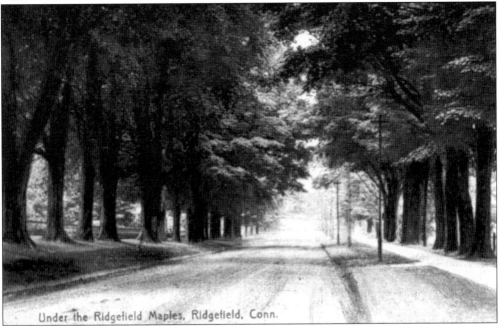

Under the Ridgefield Maples, Ridgefield, Conn.

UNDER THE RIDGEFIELD MAPLES. Ridgefielders were proud of their tree-lined Main Street and produced many cards that emphasized trees more than buildings. In color, this German litho card offers beautiful greens, reds, orange, brown, and tan tones. The card, postmarked 1908, looks northward from near the library.

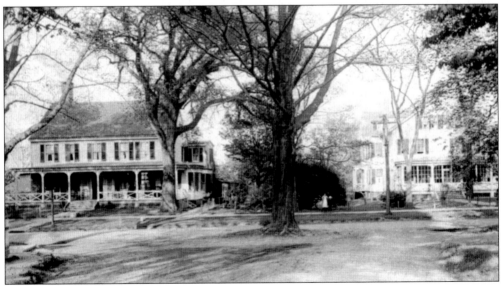

THE ELMS INN. This real-photo shot from *c.* 1910 shows something remarkable: there used to be a large tree growing in the middle of the intersection of Gilbert and Main Streets. There appears to be little or no island of grass associated with the tree. Traffic was just not a problem back then. More views of the Elms appear on pages 6 and 67.

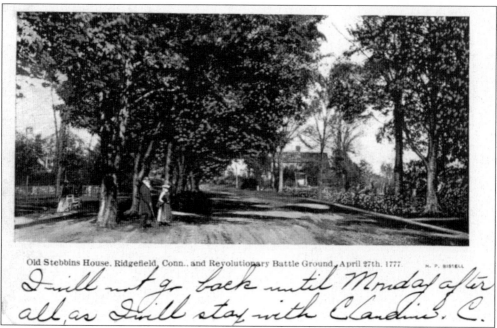

Old Stebbins House. Ridgefield, Conn., and Revolutionary Battle Ground, April 27th. 1777. H. P. BISSELL

I will not go back until Monday after all, as I will stay with Claudine. C.

THE OLD STEBBINS HOUSE AND REVOLUTIONARY BATTLEGROUND. While this card was published *c.* 1904, the image on it is from a photograph believed to be from the 1870s or 1880s. The Stebbins house, a hospital during the Battle of Ridgefield, is in the background (see pages 122 and 123 for a better look). The saltbox was razed in 1892 to make way for Casagmo (below).

MAIN STREET, THE SITE OF THE 1777 REVOLUTIONARY BATTLE. Underwood & Underwood produced this real-photo image of northern Main Street *c.* 1910. Barely visible through the trees is the Casagmo mansion that replaced the Stebbins house (previous card). At the extreme right is a portion of the gatehouse at Casagmo, and in the stone wall in front of it is the battle monument (see next page).

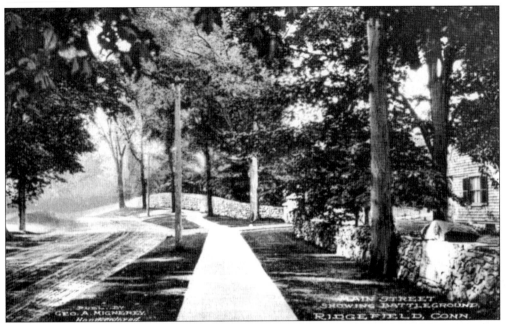

MAIN STREET, SHOWING THE BATTLEGROUND. The Casagmo gatehouse and the monument in the wall are shown in this pretty, hand-colored Albertype card from *c.* 1915.

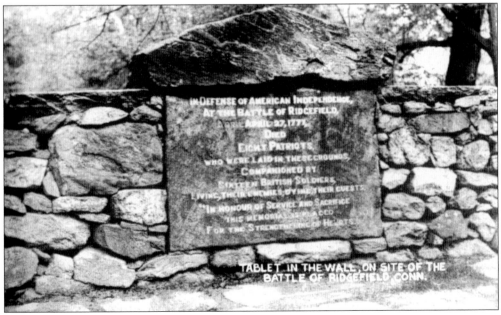

THE TABLET IN THE WALL, THE BATTLE OF RIDGEFIELD SITE. The memorial in the Casagmo wall is still there and still easily readable. The unmarked soldiers' burying ground behind it was deeded to the town *c.* 1968, when the Casagmo estate was developed into the Casagmo apartments, now condominiums. The burying ground is now a small woods.

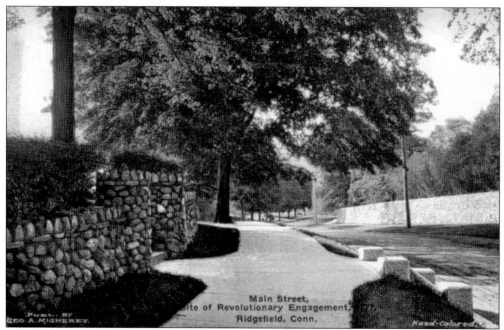

Main Street, the Site of the 1777 Revolutionary Engagement. This view, looking northward from the sidewalk on the west side of Main Street opposite Casagmo's entrance, is much the same today as it was in 1915, when this scene was photographed.

Main Street, Looking Southward from the Old Stebbins Place. Here, facing away from the previous views, the scene down Main Street is once again dominated by trees. The title suggests the card is based on an old picture, since the Stebbins place had been torn down in 1892, more than 10 years before this card was published. If it were contemporary, the label should have said, "looking south from Casagmo."

Two
VILLAGE BUSINESS DISTRICT

*Two blocks in the village have served as the hub of government
and commerce since the early 19th century.*

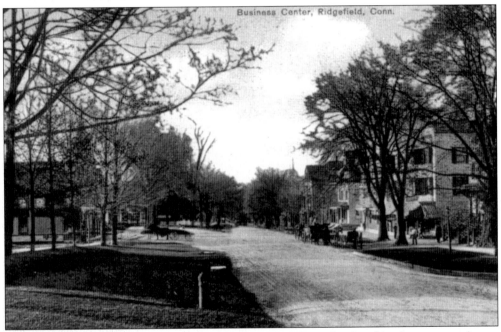

THE BUSINESS DISTRICT. Things were quiet in the village the day this picture was taken—compared to the more bustling scene on page 24. Postmarked 1911, this German litho card looks northward from opposite Governor Street. The view was created long before the Ridgefield Savings Bank building was erected where the Gage Block (page 24), holding shops and apartments, is at the right. The laundry belonged to "John the Chinaman," reports historian Silvio Bedini. He was a popular figure who worked 40 years to save enough to return to China with some wealth. On his journey home, "he was robbed on his way through San Francisco and disappeared, possibly a victim of foul play," Bedini says.

THE BUSINESS SECTION OF MAIN STREET, BEFORE THE FIRE OF 1895. In December 1895, a fire broke out in the Bedient building at the corner of Main Street and Bailey Avenue, left of where this photographer was standing. The blaze quickly spread to nearby structures along the east side of Main Street—the buildings shown here were among those lost. The town hall, also destroyed, was off to the left. A tree in front of it is visible, with a sign leaning against it. The sign was probably the public notices board, warning of upcoming town meetings and such. The

first building visible is the old Masonic Hall. The doorway on the side was used as the entrance to the Ridgefield Press, which occupied the first floor. The modern-day Masonic Hall stands on the same site. The fencing at the right side of the picture is in front of the Methodist church at Main and Catoonah Streets. The large sign at the south side of Catoonah Street advertises Whitlock's Livery Stable, which stood on Catoonah Street opposite the firehouse (see page 40).

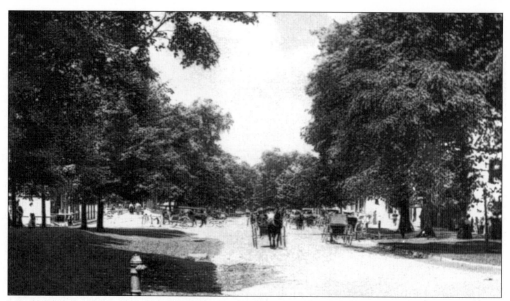

MAIN STREET. This view is very similar to the one on page 21. An earlier card, it was probably photographed *c.* 1905 and definitely after 1900, when the hydrant in the foreground was installed. Something important must have been going on in town, judging from the number of people and horses shown.

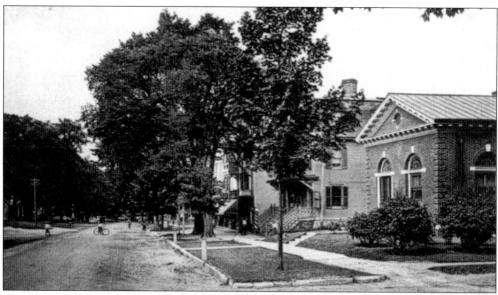

MAIN STREET, THE BUSINESS SECTION. A boy on a bicycle stands in the middle of Main Street, probably watching the photographer, in this shot from *c.* 1915. Another boy in the distance is riding toward the camera, and still another is sitting in the grass near the barber pole. It must have been summer. The card offers a good view of the Gage Block, the building that housed shops and apartments just north of what is now First Union Bank. To build its first real headquarters, Ridgefield Savings Bank bought the Gage Block in 1928 and moved it a couple hundred feet east and a couple hundred north, where it remained until the 1950s, when it was torn down to make way for the shopping center that includes Hay Day Market (see aerial view on page 42). The new bank was erected in 1930 (see next page).

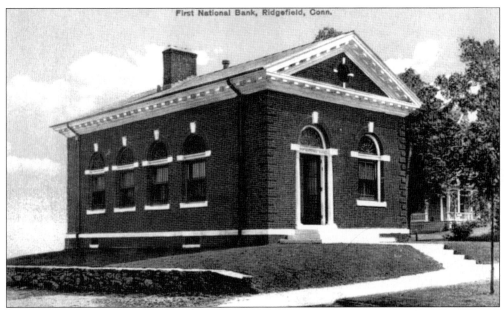

FIRST NATIONAL BANK. First National Bank and Trust Company of Ridgefield was formed in 1900 and, 10 years later, built this brick office on the corner of Main and Governor Streets. The bank went through a succession of owners, including Union Trust Company. First Union Bank took it over in the 1990s, and by pure coincidence, its own name combined the first names of the first and last previous owners of the institution. In the right background is the old house that is now the real estate office of Coldwell Banker. Look closely and you will see a dog lying on the porch, a testament to the quality of the camera lens and printing process. The blank horizon at the left is untrue; there would have been buildings there, but employing "postcard license," the card publisher erased them from the negative.

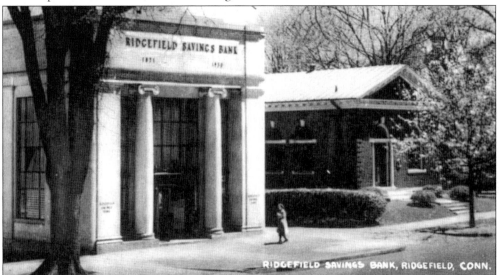

RIDGEFIELD SAVINGS BANK, RIDGEFIELD, CONN.

RIDGEFIELD SAVINGS BANK. That is the title of the card, but also prominently shown is the savings bank's chief competition, First National Bank and Trust Company of Ridgefield. The card probably dates from the 1930s. The art deco bank was erected in 1930, and although no longer the bank's headquarters, it serves as the village office of Ridgefield Bank.

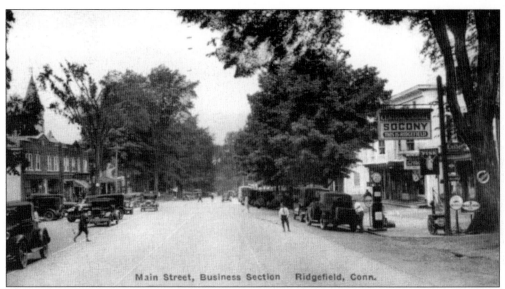

Main Street, Business Section Ridgefield, Conn.

MAIN STREET, THE BUSINESS SECTION. Children seemed to love to stand in the road when the postcard man appeared (see pages 24, 34, and 35, for instance). Here, they are from the late 1920s; the card was postmarked 1929. The view is remarkable in that it shows a filling station, or gas station, right in the middle of the village. Imagine what the town fathers would say today if Shell or Amoco wanted to open up on Main Street—and with all those signs. The Central Garage operated out of what is now Gail's Station House restaurant and also sold Dodge cars and trucks. Signs advertise Fisk tires, Exide batteries, Wolf's Head oil, Mobiloil, and of course, Socony gas (Standard Oil Company of New York, now Mobil). Also visible is a Rider's Ice Cream sign, probably on Bissell's drugstore next door. The Socony sign also says, "This is Ridgefield." For tourists wandering in their automobiles, locales were not always clearly marked; Central Garage's sign served the same purpose a sign at a train station does.

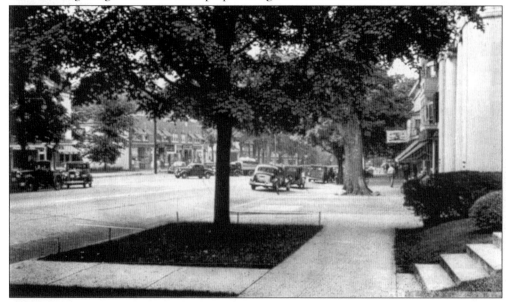

MAIN STREET. A late-1930s view from in front of today's First Union bank shows, in the distance, the overhead sign for H.P. Bissell's drugstore.

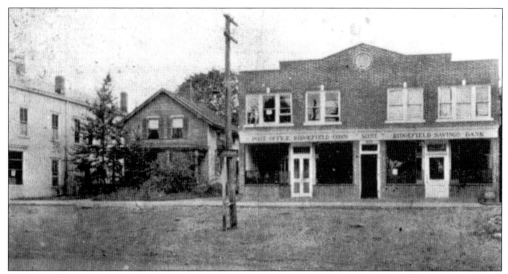

THE POST OFFICE AND RIDGEFIELD SAVINGS BANK. Although a poorly printed image, this postcard shows a very recognizable scene today as it appeared in the 1920s. In the brick building, the post office is at the left, where Addessi Jewelers is now, and Ridgefield Savings Bank is at the right, where Ridgefield Office Supply is now. Ernest Scott built the building and the one unseen to its right, which together are often called the Scott Block; his name appears over the doorway to the upstairs offices. The house to the left was moved *c.* 1948 to make way for Ridgefield Hardware; for a while it stood out back, but it was eventually torn down. At the left is the old Perry's Market building, later Gristede Brothers Market, which now serves as shops and offices. In the message on the back of the card, the sender says: "Am spending two days with a friend in Ridgefield. I always enjoy a visit here; it is such a restful spot."

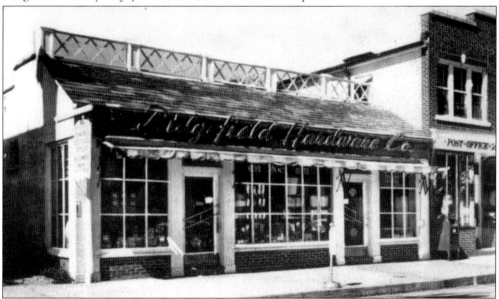

RIDGEFIELD HARDWARE. The store looks much the same today as it did in 1948, when this photograph was taken. Many of the items displayed in the windows then are probably being shown in antiques stores today. The post office was next door (right) from 1922 until 1959, when it moved to the Grand Union shopping center, where CVS is now.

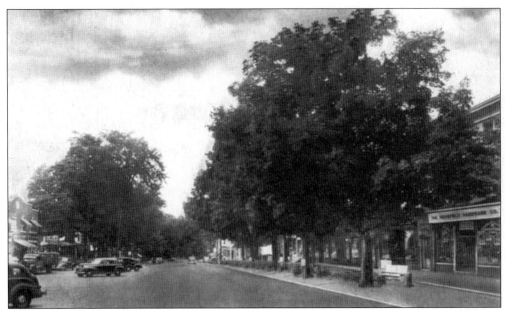

MAIN STREET. Ridgefield Hardware's original store is prominently displayed at the right of this card, published by Ridgefield Hardware itself. Edward Rabin established the store in 1938, and his son, Jerry Rabin, owned it in 2003, making it the oldest retail business operated by one family in the village. The image shows Ridgefield just after World War II.

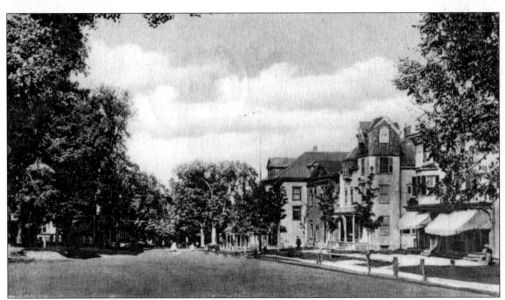

THE BUSINESS SECTION OF MAIN STREET, LOOKING NORTHWARD. About the only vehicle visible in this view is the bicycle, just south of the Masonic Hall (the building with the four-story tower). The town hall is just beyond the Masonic Hall, and the old Bedient building is beyond that. The card is postmarked 1908, but the picture was probably taken five to eight years earlier.

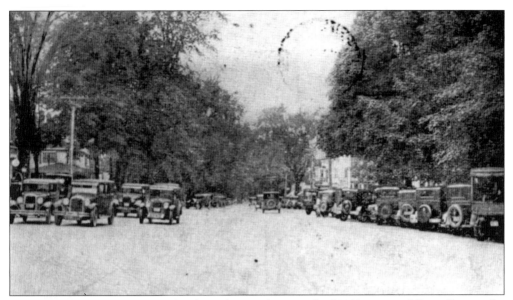

MAIN STREET, THE 1920s. What brought out this crowd of 1920s automobiles will never be known, but the fact that so many cars were parked along Main Street *c.* 1928 may surprise those who complain about not being able to find a parking space today. Hidden behind the trees at the right is the town hall; beyond the cars at the left is the Scott Block. Notice how the cars there are parked, and compare the arrangement to those in the next two cards.

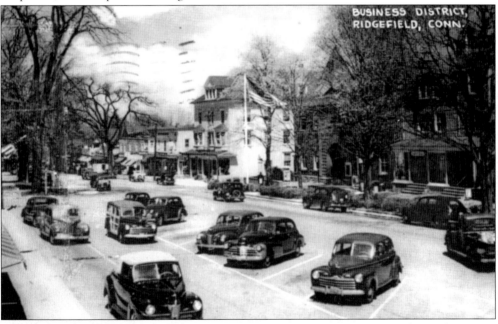

THE BUSINESS DISTRICT, THE 1940s. This arrangement of parking spaces in front of the Scott Block was tried in the 1940s. If you look closely at the left side of the picture, you will see that, to make the scene more attractive, postcard publisher Collotype removed a utility pole that stood at the edge of the sidewalk. The town did the same thing *c.* 1980. In a beautification effort, officials had the power and telephone companies remove all utility poles from the two business blocks of Main Street. The wires were put underground.

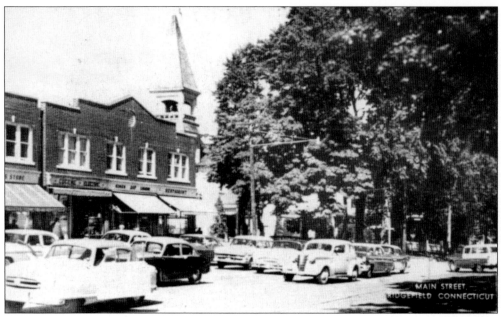

MAIN STREET, THE 1950S. By the early 1950s, the town was back to using the three rows of parallel parking (with a lane running through them), a system that looks quite confusing. The shops visible in the Scott Block are, from left to right, Ridgefield News Store, Cugene Electric, A & P Liquors, and a restaurant, probably operated by Alex Santini.

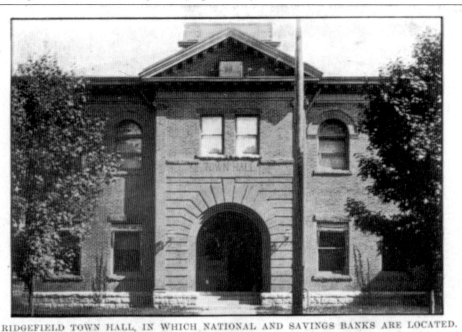

RIDGEFIELD TOWN HALL, IN WHICH NATIONAL AND SAVINGS BANKS ARE LOCATED.

RIDGEFIELD TOWN HALL, WITH FIRST NATIONAL AND RIDGEFIELD SAVINGS BANKS. The two local banks, Ridgefield Savings and First National, started out with offices in the town hall and later wound up side by side at the other end of the block. The banks were on the left side as you walked in the front door, and the town clerk was on the right. The picture is from *c.* 1905.

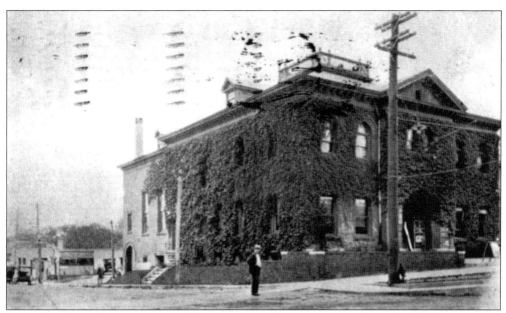

THE TOWN HALL. When the brick town hall was built in 1896 to replace the wooden building destroyed in the Fire of 1895, it included a bay for the fire department's apparatus. You can see the opening toward the rear of the building along Bailey Avenue. This image is probably from the early 1920s, long after the firehouse had moved to Catoonah Street but before the garage bay was bricked over. The rear portion of the main floor of the building was literally a hall, the site of not only town meetings but also movie and stage shows, basketball games, and formal dances. For many years part or most of the town hall was covered in ivy, but in the 1980s, officials decided that the plant caused the brick to deteriorate and had the vines removed. Just visible behind the town hall is Coleman's Lunch stand and, beyond it, a garage that later became today's Ridgefield Press headquarters.

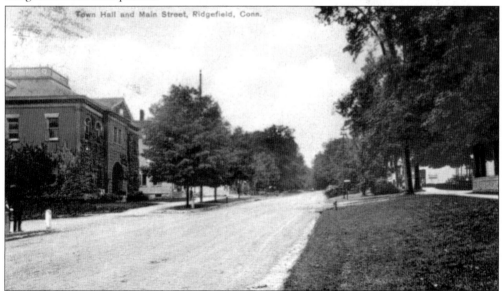

THE TOWN HALL AND MAIN STREET. Postmarked 1908, this German litho card shows how grassy the edges of Main Street were, even in the business district.

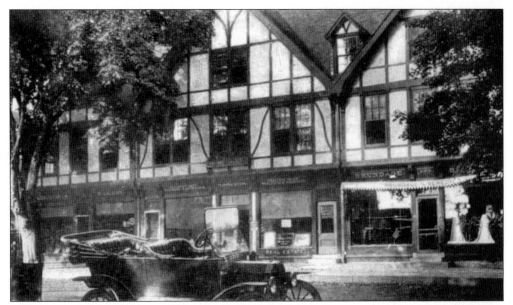

THE TELEPHONE BUILDING. The still-standing Tudor block, erected *c.* 1913 by Lucius Biglow (page 46), has had several names over the years, but the sign on the front over the door to the upstairs says, "Telephone Building." The telephone company did not own it but had its local office upstairs, where the operators would keep Ridgefielders in touch with one another and with the outside world. Ground-floor stores were, from left to right, Ridgefield Bakery; McCarthy Brothers, Plumbers-Electricians; Thaddeus Crane, Real Estate, Insurance; and Brundage & Benedict dry goods. Thaddeus Crane met a spectacular demise in 1928, when a train hit his Hudson sedan at a crossing in Wilton, hurling the automobile into the air. The car landed atop the second engine, flipped onto a trackside signal box, and exploded.

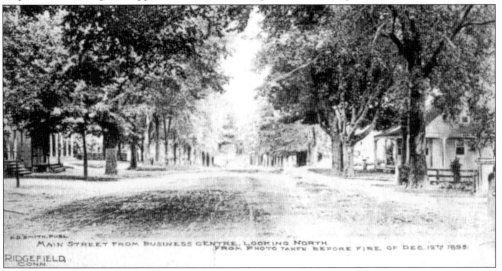

MAIN STREET, LOOKING NORTHWARD FROM THE BUSINESS CENTER, BEFORE THE FIRE OF DECEMBER 12, 1895. This card is the mate to the view on pages 22 and 23. Its long-winded title is a little misleading since the fire affected nothing here. At the right is the Lannon house, now called Tuppence, which was moved to lower Main Street. It sat about where the Gap is today. The many-columned porch at the left probably belonged to a store.

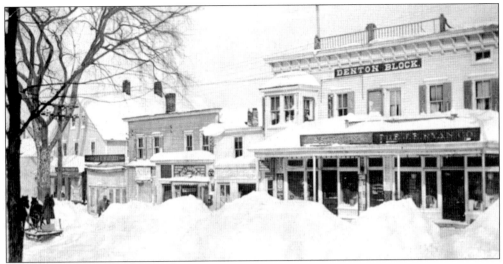

THE DENTON BLOCK. Across the road from the Telephone Building was the Denton Block, captured in this real-photo shot of a snowstorm's aftermath, probably between 1910 and 1920. Coal and hardware merchant S.S. Denton owned many of the buildings here. Shown, from left to right, are the old Lannon house, or Tuppence, barely visible here (see page 32); the "new" A & P; Henry Kuhlmann's Modern Grocery; Oscar Schultze's meat market; an unidentified store; Charles Wade Walker's Happy Shop; F.L. Bailey's electrical contracting office; John Hubbard's radio store; an auto supply store; and J.E. Ryan, selling dry goods, shoes, grain, and feed.

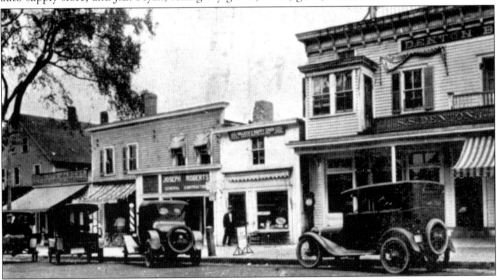

A BUSINESS BLOCK. A look at the east side of Main Street a few years later than the previous view shows that Walker's Happy Shop has moved one door south. Walker, who was also a local musician (page 87) and policeman, explained his business in an advertisement c. 1920: "Toys to make the kiddies happy, sweets to make the ladies happy, and smokes to make the men happy." The windowed projection on the second floor of the Denton Block was S.S. Denton's office—he had the extension built so he could keep an eye on what was happening up and down Main Street. The barbershop belonged to Conrad Rockelein, who, besides cutting hair, dabbled in real estate and subdivided Mountain View Park, the Danbury Road neighborhood that includes Island Hill, Hillsdale, and Mountain View Avenues.

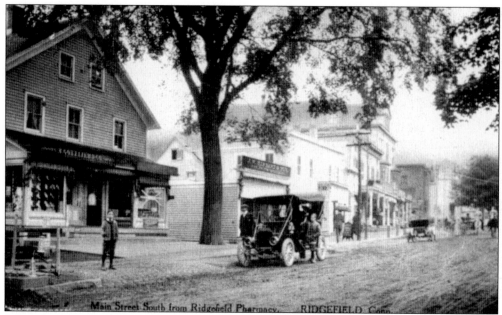

MAIN STREET, LOOKING SOUTHWARD FROM RIDGEFIELD PHARMACY. This charming view, complete with a couple of ever-present children, shows the east side of Main Street from a different angle. At the left is Morris Gottlieb's shoe store. Gottlieb began his career as a peddler with a cart, opened this shop, and wound up moving to Manhattan, where he operated a successful store. Behind the automobile is J.W. Hibbard and Son's meat and fish market. Notice the two riders on horseback at the extreme right.

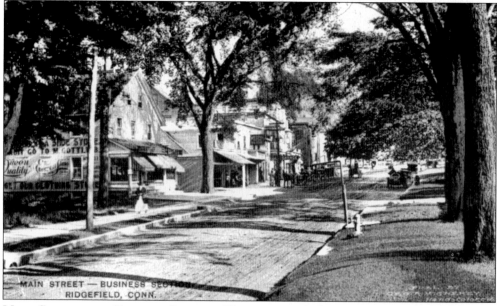

MAIN STREET, THE BUSINESS SECTION. The camera is farther north to capture this shot that shows the old-fashioned technique of painting the side of a building with advertising. Here, Morris Gottlieb promotes his shoe store and adds, "Don't forget our clothing store." There are also blurbs for various shoe brands.

34

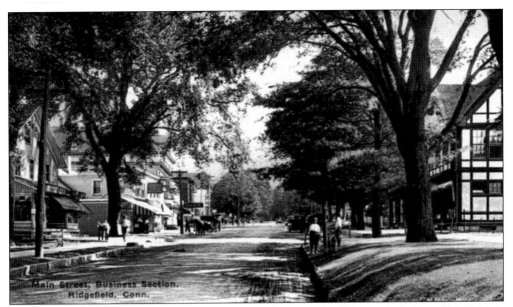

MAIN STREET, THE BUSINESS SECTION. Yet another view looking southward—with still more knickered youngsters—shows the Telephone Building to the right. Notice the sign for the "garage" near the Denton Block. The card is postmarked 1920.

MAIN STREET, LOOKING SOUTHWARD FROM THE LIBRARY. Where the shops and offices of Yankee Ridge are today were houses at the beginning of the 20th century. From left to right are, just barely visible, the porch of the Osborn house (where Winifred Osborn grew up—see page 93), which was torn down for Yankee Ridge in the 1970s; the home of Dr. Howard P. Mansfield, about where Chez Lenard, the "hot dog" man, parks now; the Dauchy house, which was moved back in the 1920s, when stores north of the building housing the Gap were built and which was torn down in the 1960s; and the Lannon house, now Tuppence, moved to southern Main Street. Many of the rest of the barely visible buildings still stand. What is now the CVS shopping center, at the right, was little more than fields back then.

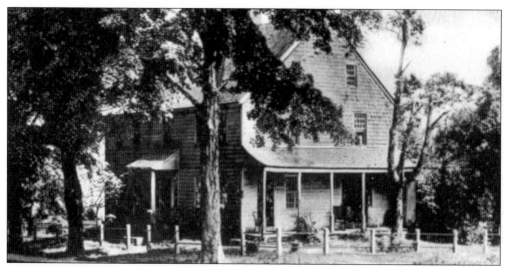

LANDLORD SMITH'S TAVERN. The north corner of Main and Prospect Streets was once the home of the Smith Tavern, a popular 19th-century watering hole and meeting place. Amos Smith built the place in 1797 and even had a mill down the hill to create his own cider for the tavern—cider probably being the most popular alcoholic beverage in the 19th century. The second floor included a ballroom, where dances and meetings took place. When Evelyn Smith sold the place to the library in 1900, it ended uninterrupted Smith ownership of the land that began at the town's founding in 1708.

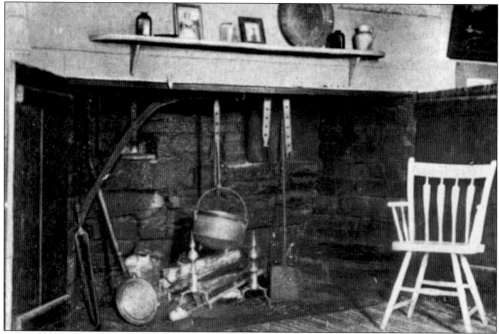

THE FIREPLACE IN THE DINING ROOM OF LANDLORD SMITH'S TAVERN. Very few postcards showed interiors, but this view of the old fireplace was a fairly popular card and appeared in a couple of editions. The construction of the fireplace suggests that it may have been older than the tavern, which had been built on the site of the Smith family homestead. Perhaps the fireplaces and chimney survived when the house was destroyed, deliberately or by accidental fire, in 1797.

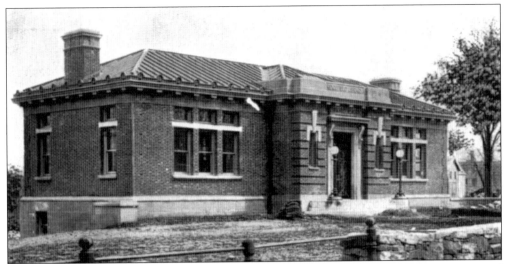

THE RIDGEFIELD LIBRARY. The new quarters of the Ridgefield Library opened in 1901, and this picture appears to have been taken while construction was still going on.

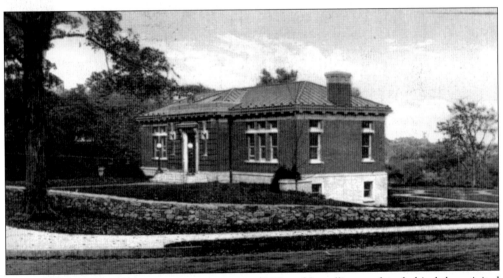

"ELIZABETH K. MORRIS MEMORIAL LIBRARY." The old strolling gardens behind the original library building are visible in this litho card, printed in Great Britain. Either the local publisher, H.E. Smith's pharmacy, or the printer goofed, though; the library was a memorial to Elizabeth *W.* Morris, whose husband made a sizable donation toward the building's construction. The card offers evidence of how good mail service was back in 1907. It was postmarked from Ridgefield at 11:30 a.m. on August 19 and was received in Ann Arbor, Michigan, at 10:13 a.m. on August 20. The card traveled from Connecticut to Michigan in less than 23 hours.

THE RAILROAD STATION AND VICINITY. The view down Prospect Street from Main Street was pretty empty *c.* 1905 except for the train station at the foot of the hill. A barely visible building on the south side of the road was once the Brunetti and Gasperini Italian food market. Later, it was Carboni's Italian restaurant, before being torn down to make way for the Yankee Ridge shopping center in the mid–1970s.

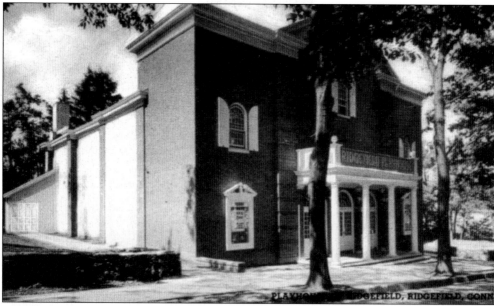

THE PLAYHOUSE OF RIDGEFIELD. The date of this card is easy to figure out. The signboard on the front of the building says the movie playing was *Torrid Zone,* which was released in 1940, the same year the Ridgefield Playhouse opened. The playhouse continued to show movies and have occasional stage shows until 1973, when it was sold to Village Bank and Trust Company, which turned it into its bank headquarters. The playhouse is now a Webster Bank branch, but the Ridgefield Library—which sold the land to the playhouse *c.* 1939—now owns the land again, complete with building.

38

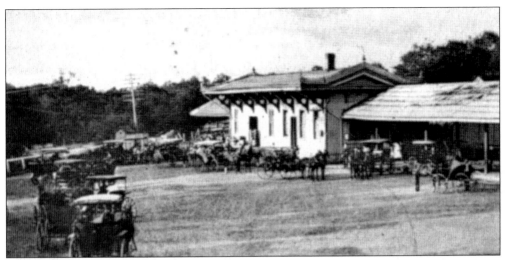

THE RIDGEFIELD DEPOT. The Ridgefield Station was a busy commuting spot, and sometimes dozens of carriages would arrive to drop off or pick up passengers. The station was built in 1870 and continued to offer passenger trains between Ridgefield and Branchville (pages 105 and 106) until August 8, 1925, when service was abandoned because the popularity of the automobile. Freight service continued until February 1964. The ornate station is now a warehouse at the Ridgefield Supply Company, which has preserved it from destruction. This very early German color card was mailed in 1906.

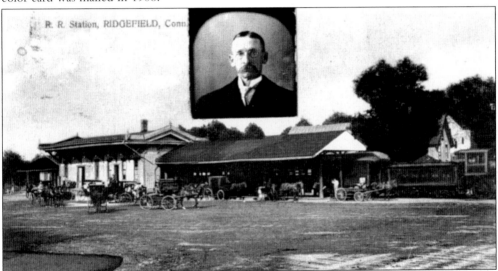

THE RAILROAD STATION. People sometimes customized their postcards. This unsigned card, mailed in 1908 to Miss Maud Dewitt of Poughkeepsie, New York, included a pasted-on portrait—presumably of the sender. The fact that he placed his face on a railroad station card may have meant that he was taking the train to see Maud—or was expecting her to arrive on the train. One hopes he looked happier at the meeting. The view of the station from the middle of Prospect Street, looking northeastward, shows a parked engine of the New York, New Haven and Hartford Railroad, with at least one car. To return to Branchville, the train backed down the five-mile track, which descended some 400 feet in elevation, acting more like a brake than a power source. In 1905, one of these engines, perhaps this one, derailed while backing to Branchville, scalding the engineer to death.

A View from the Methodist Church Corner. Catoonah Street was also a service and commercial locale in the village. This view, from in front of the Scott Block, looks northward across Catoonah to the Methodist church complex. At the right is the Denton Block, on the east side of Main Street. The card predates 1913 because the Tudor-style Telephone Building has not yet been erected beyond the Methodist property. The card was sent to a Stamford woman with this note: "What do you think of this city? A good place to rest, I'll say."

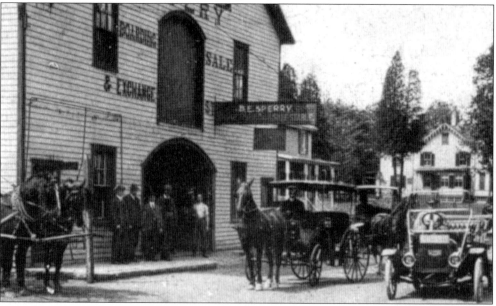

B.E. Sperry's Livery Stable. No postcard symbolized the changing times on the roads of early-20th-century Ridgefield better than this. Both horse-drawn carriages and the automobiles that drove them to oblivion are parked side by side in front of a livery stable, a place for housing and renting horses and a dying remnant of the 19th century. B.E. Sperry took over the stable from the Whitlock family in 1897 and had as many as 75 horses at one time. The building was on Catoonah Street opposite the firehouse. As the popularity of equine transportation faded, Sperry turned to taxicabs and a coal and wood business. He died in 1946. Two years later, under the weight of a heavy snowfall, the building collapsed with a roar of splitting timbers.

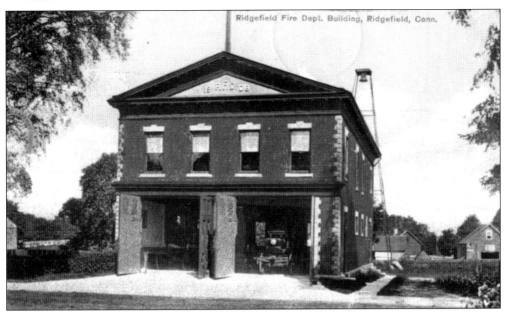

THE RIDGEFIELD FIRE DEPARTMENT BUILDING. The Fire of 1895, which destroyed half of the village businesses, sparked the establishment of a real fire department, and the first quarters were in the town hall cellar (see page 31). In 1908, a freestanding firehouse was erected on Catoonah Street a short distance from Main Street—and is still in use today. This German litho card was mailed in 1912, but the image is probably from *c.* 1910. The tower out back holds the bell that was sounded to rally volunteers when a fire report came in. The apparatus at the left appears to be horse drawn, and the engine in the right bay may have been self-propelled.

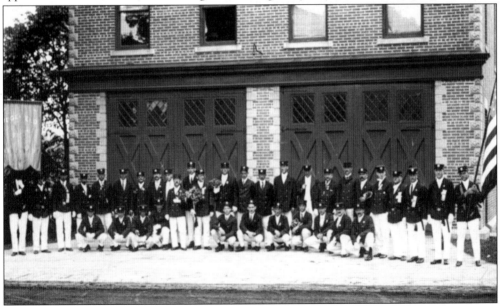

FIREFIGHTERS. This real-photo portrait of the members of the Ridgefield Fire Department was taken probably *c.* 1910. The dress uniforms suggest the firefighters are ready for a parade. The shot was probably commissioned by the department, and the resulting postcards were distributed to the men.

41

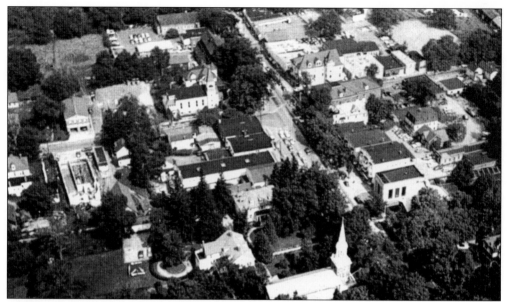

AERIAL VIEW NO. 1. In the early 1950s, Ridgefield photographer George A. Mench got into an airplane and took two shots that were turned into postcards and that record the village shortly before many major changes occurred. In this view, looking northward, St. Stephen's Church is at the bottom. The Grand Union-CVS shopping center, the town's first shopping center, had not yet been built in the area at the upper left, which was still largely open field. The Donnelly shopping center that today houses Hay Day Market also did not exist—note the old buildings that used to stand in that area. The building with the mansard roof, southeast of the town hall, was called the Gage Block and originally stood where Ridgefield Bank is now (see page 24).

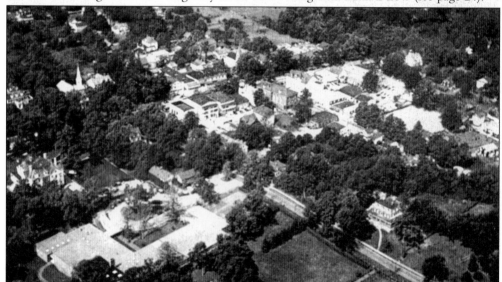

AERIAL VIEW NO. 2. This photograph looks northeastward, with the then-new Veterans Park School at the lower left. The house toward the upper right, surrounded by trees, was the old Osborn place, at the corner of Main and Prospect Streets. Note all the fields in the upper center. Some of those are now the CVS shopping center, Ballard Green housing for the elderly, and Victoria Gate condominiums.

Three
MAGNIFICENT HOMES

While they were called "cottages," the country homes of wealthy
New Yorkers and others were more like mansions.

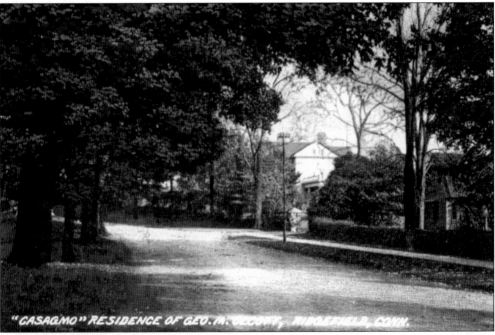

"CASAGMO" RESIDENCE OF GEO. M. OLCOTT, RIDGEFIELD, CONN.

CASAGMO, THE RESIDENCE OF GEORGE M. OLCOTT. Looming over the head of Main Street throughout the first half of the 20th century was the Italianate mansion Casagmo. Built in 1893, the house was named for its owner, who combined *casa,* the Italian word for house, and his own initials to create Casagmo. The house was razed in 1968 to make way for the 320-unit apartment complex, since converted to condominiums, also called Casagmo. Only the barn and the stone wall—including the gateway shown here—remain from the 21-acre estate. (For a look at what was here before 1893, see pages 122 and 123.)

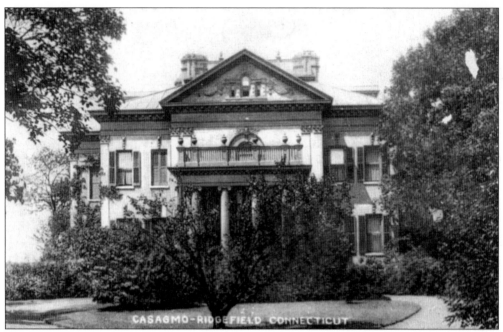

CASAGMO, FRONT VIEW. George M. Olcott, who was a pharmaceutical manufacturer, died early in the 20th century, and the house was left to his maiden daughter, Mary Olcott, a poet, genealogist, naturalist, and suffragist. She lived there until her death in 1962 at the age of 97.

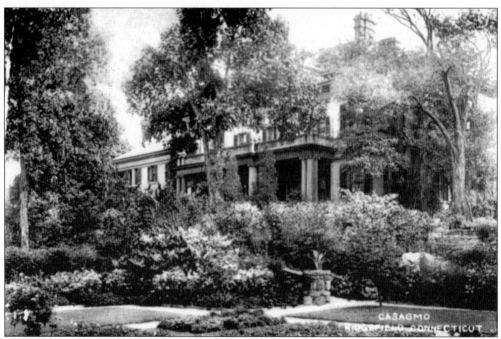

CASAGMO, REAR VIEW. Mary Olcott, a founder of the Ridgefield Garden Club, maintained—with the help of groundskeepers, of course—an elaborate garden. The lush growth at the back of the house is shown in this card.

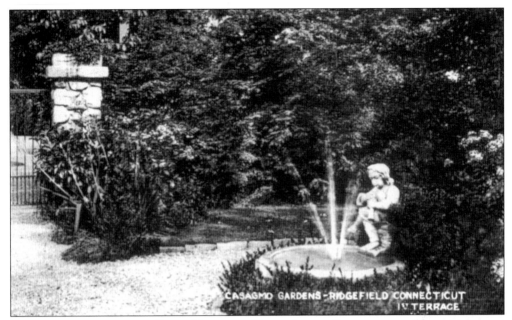

CASAGMO GARDENS, THE FIRST TERRACE. The gardens at Casagmo were designed in several terraces along a slope.

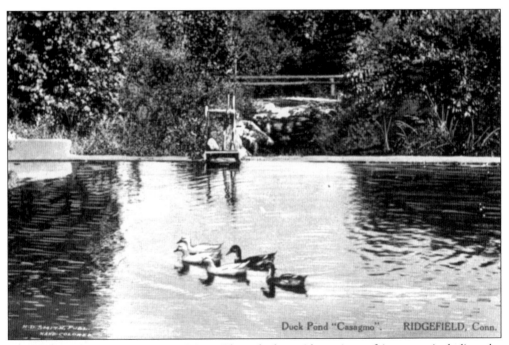

THE DUCK POND, CASAGMO. Mary Olcott had a wide variety of interests, including the breeding of game birds, poultry, and swans, as well as poodles. This body of water was presumably more of a swan pond than a duck pond, as it is labeled in this early Albertype hand-colored card from *c.* 1915.

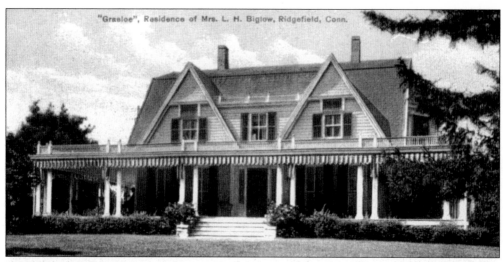

GRAELOE, THE RESIDENCE OF MRS. L.H. BIGLOW. Music publisher Lucius H. Biglow bought an 18th-century Ridgefield home in 1889, dressed it up, and named it Graeloe after his wife's maiden name and his own. The house had once been the home of Revolutionary War leader Col. Philip Burr Bradley. Biglow's daughter Elizabeth B. Ballard, another Ridgefield Garden Club leader, later lived here. She died in 1964 at age 88, and in her will she left this estate to the town as a park, requiring that her house be torn down so it would not be a burden on the community. Today, the land in front is Ballard Park and the land in back holds Ballard Green housing for the elderly. The local garden clubs use the greenhouse.

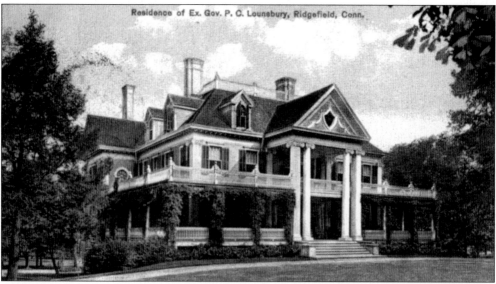

THE RESIDENCE OF P.C. LOUNSBURY, FORMER GOVERNOR. When he attended the Columbian Exposition in 1893, Phineas C. Lounsbury was taken by the design of the Connecticut building there and decided to model his new Main Street house, called Grovelawn, after it. Elected Connecticut's governor in 1887, Lounsbury moved his previous house to Governor Street, where it still stands as an office building next to the municipal parking lot. This view is postmarked 1913. Lounsbury died in 1923, and the town acquired the estate in 1945 and named the block of property Veterans Park. The mansion is now the Ridgefield Community Center, and the backlands hold Veterans Park School and fields (see page 178 for an early view of the fields).

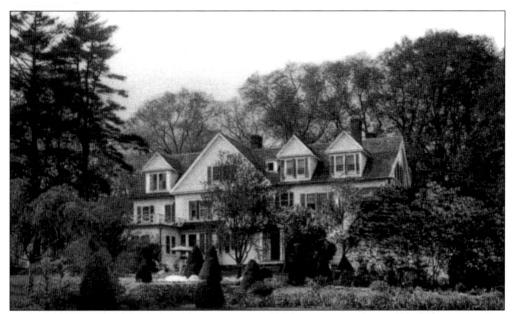

THE "RESIDENCE OF MRS. [VAN] ALLEN SHIELDS." Just south of the Ridgefield Community Center is the home of Laura Curie Allee Shields, another pillar of the community and of the garden club. This view shows the south side of the house, which looks much the same today. Laura Shields was active in the suffrage movement and worked with then U.S. Sen. Warren G. Harding on helping get the 19th Amendment passed in 1920. Among her friends in the suffrage movement was the mother of actress Katharine Hepburn.

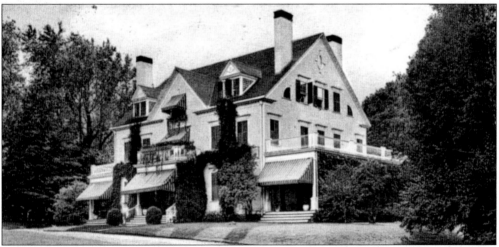

THE RESIDENCE OF MRS. J. HOWARD KING. Since shortly after the Revolutionary War, members of the King family had lived at the corner of Main Street and King Lane. Revolutionary War Lt. Joshua King was a founder of the King and Dole store, part of which is now the Aldrich Museum. His "mansion" burned in 1888 and this house, probably a bit larger and set back farther from the road, was built as a replacement. The King family sold the place in the 1920s, and for several decades, it was the home of the Jackson family. It has gone through a number of owners in recent years, and it survived a fire in the early 1990s. This card is postmarked 1924. In the front-most third-floor window on the end of the house, there appears to be a face, probably of a maid, looking out at the cameraman.

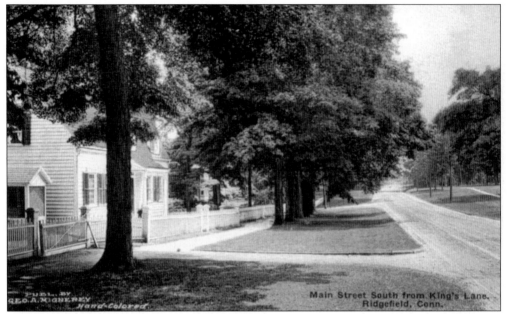

THE HAULEY HOUSE. The town fathers built this gambrel-roofed house *c.* 1713 for the town's first minister, Rev. Thomas Hauley, a 1709 Harvard graduate who had been ordained in 1712. Until 1888, his church, or meetinghouse, stood on the town green on the other side of Main Street, just beyond the right edge of this card. Reverend Hauley was the town schoolteacher and the town clerk as well as the minister of the First Congregational Church. He died in 1738, and his gravestone still stands in good condition in the old town cemetery. The outside of the house has changed little in appearance in the last century and probably looks much as it did in the early 1700s.

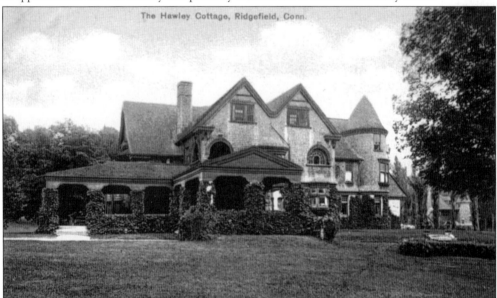

THE HAWLEY COTTAGE. Across Main Street from the ancient Hauley House, Irad Hawley, a local merchant who was a descendant of the first minister, built this magnificent cottage in the 1890s. In the right background is the carriage house that now serves as Odd Fellows Hall on King Lane. The house soon took on a new look, however. See page 49.

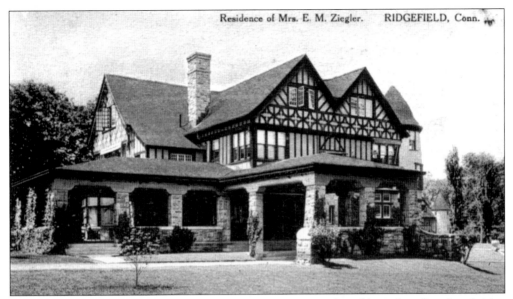

THE RESIDENCE OF MRS. E.M. ZIEGLER. By 1920 or so, when this card was produced, Mrs. Ziegler or someone else had decided the Hawley design was unsuitable and converted it—and the carriage house—into Tudor style. The mansion is still there today in all its glory. Most people do not see it, however, because it is hidden behind the massive brick Jesse Lee Memorial United Methodist Church. The congregation bought it from the Freund family in 1958 and uses it for church school and other functions, calling it Wesley Hall.

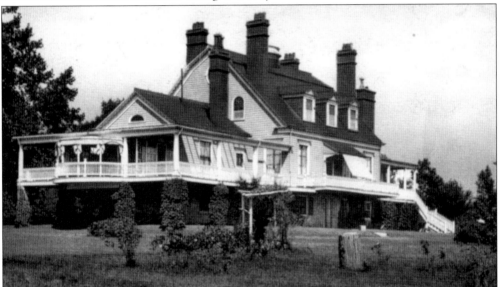

BEACON HILL COTTAGE. A few estates were built on the highlands of Wilton Road West (Route 33) south of Main Street. Dr. Newton M. Shaffer erected his cottage off the east side of the road. The name recalls the story that, at this spot after the Battle of Ridgefield, British troops built fires to signal their ships at Compo in Westport. The house still stands, but the porches and most of the six chimneys are gone. Shaffer, who died in 1928, was an orthopedic surgeon who became world renowned for his work with children. He was also an outdoorsman, and the Library of Congress has an 1880s photograph of him with his fly rod at a Maine fishing site.

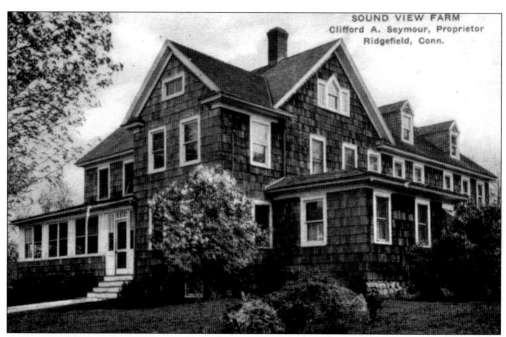

SOUND VIEW FARM. Farther down Wilton Road West just below St. Johns Road is Sound View Farm. This was not a summer cottage like most of the others in this chapter, but the large home of Clifford A. Seymour, a descendant of the first founders of the town, who had a sizable farm here. For a while in the middle of the 20th century, it was the Knights of Columbus Hall.

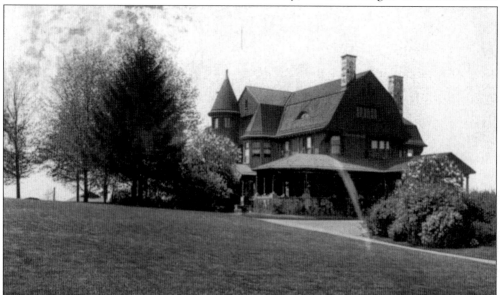

THE RESIDENCE OF E.P. DUTTON. Edward Payson Dutton, the book publisher whose name is still a book imprint, built his home on High Ridge in the 1890s. The house has not changed much in the century since. Dutton helped the town build its first large school, the Benjamin Franklin Grammar School, in 1915 (page 93). A devout Episcopalian, he was active in St. Stephen's Church and would often ride off into the countryside in his horse and buggy, stop, and read his breviary. This real-photo card was mailed in 1913. For another view, see page 120.

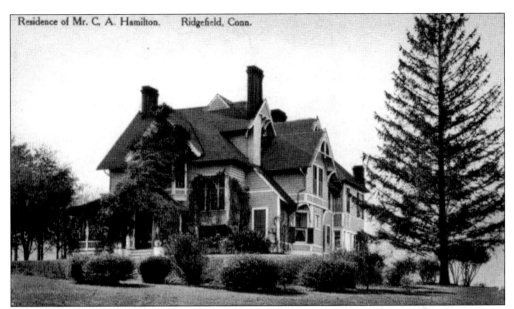

Residence of Mr. C. A. Hamilton. Ridgefield, Conn.

THE RESIDENCE OF C.A. HAMILTON. Just south of the Dutton house (page 50) was the mansion of Charles A. Hamilton, who was president of International Silver and whose son, Burgoyne, married a daughter of Supreme Court Justice Harlan Fiske and was said to have owned the first automobile in Ridgefield. A note written on the back of the card says, "House razed per Mrs. Hamilton's will." The card was probably published *c.* 1915. Today, a mansion built in 1998 stands in its place. For another view of the house, see page 120.

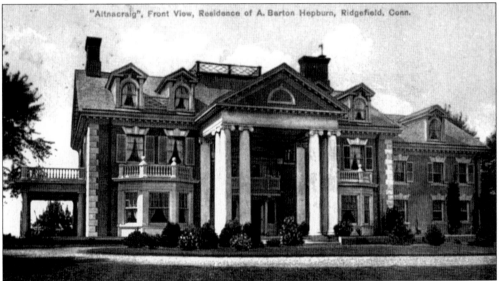

"Altnacraig", Front View, Residence of A. Barton Hepburn, Ridgefield, Conn.

ALTNACRAIG, THE RESIDENCE OF A. BARTON HEPBURN, FRONT VIEW. In 1908, Chase Bank president Alonzo Barton Hepburn had this retreat built just south of the Hamilton place. His wife, Emily, actually oversaw the project, however. After Barton was hit and killed by a New York City bus in 1922, Emily Hepburn went on to become a successful New York City entrepreneur, building and running a large hotel. Barton Hepburn was a close friend of Frederic Remington, the noted artist of the American West. On Hepburn's recommendation, Remington moved to Ridgefield in 1909, only to die here six months later from appendicitis.

51

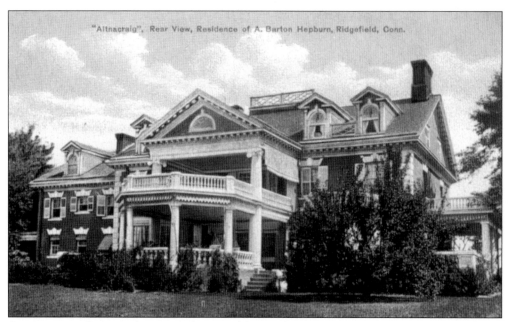

ALTNACRAIG, REAR VIEW. From the rear of the Hepburn mansion, one could see the highlands along the Hudson River 20 miles to the west. From the 1940s until the 1980s, the house served as a nursing home. In 1994, when the mansion was vacant and on the market, an unknown arsonist burned it to the ground, and a few years later, a new house was built on the site.

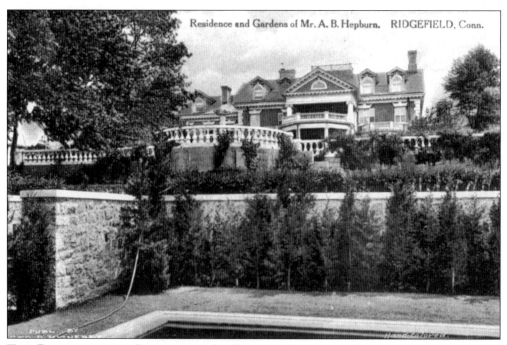

THE RESIDENCE AND GARDENS OF A. BARTON HEPBURN. This view shows the pool at Altnacraig and, beyond it, the gardens. At the right, just beyond the picture, was a pool house designed like a Greek temple. It is the only remnant of the Altnacraig estate still standing today and, in fact, was renovated and restored in 2002.

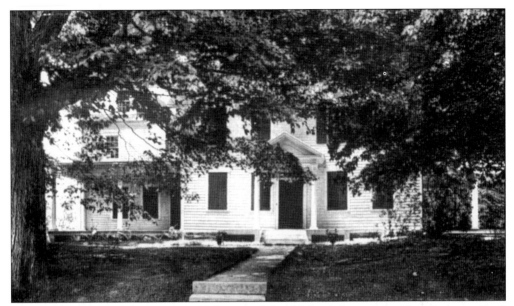

PETER PARLEY PLACE. S.G. Goodrich, son of the third minister of the First Congregational Church, was born on West Lane and, as a child, moved with his family to this house on High Ridge opposite Parley Lane. Goodrich went on to write more than 150 books, mostly aimed at schoolchildren and using the pen name Peter Parley. Because he strived to be interesting to youngsters, he has been called a pioneer of the modern textbook. The house was later used as a private school. The sender of this card in 1936 was also the owner of the house, which he or she used as a summer place. In a note to the recipient, the writer explains the shuttered windows: "This is a view of our house taken in the spring before it was open."

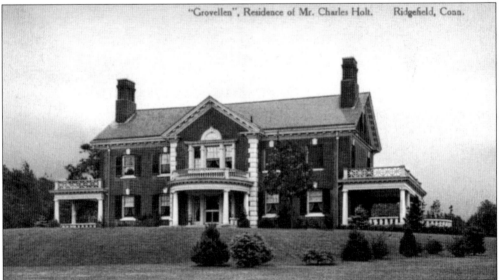

"Grovellen", Residence of Mr. Charles Holt. Ridgefield, Conn.

GROVELLEN, THE RESIDENCE OF CHARLES HOLT. High Ridge has been called Publishers Row because several people prominent in the book-publishing field lived there. Not far from E.P. Dutton lived Charles Henry Holt, who was involved in the Henry Holt publishing company. The Holt house, at the corner of High Ridge and Peaceable Street, was named Grovellen for Holt's wife, Ellen Ives Holt, but the next owner changed it to Aloha.

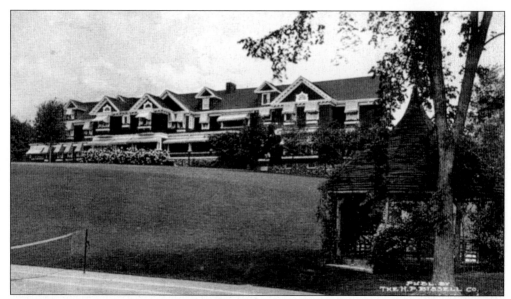

THE RESIDENCE OF ALBERT H. WIGGIN. This mansion on Peaceable Street west of Grovellen was so long that a subsequent owner ripped down part of it. Today, the place is somewhat smaller—and easier to heat. Albert H. Wiggin, a minister's son who headed Chase National Bank, was once listed among America's richest people. Later, however, he was labeled a scoundrel after it was revealed that, during the period of the Crash of 1929, he had manipulated Chase stock to his own advantage but not the shareholders'. In so doing he used loans from his own bank, put his earnings in a Canadian holding company to avoid taxes, and made millions that the bank itself did not discover until a U.S. Senate investigation several years later.

THE RESIDENCE OF GEORGE DOUBLEDAY. Across Peaceable Street from the Wiggin place was Westmoreland, the home of George Doubleday, head of the huge Ingersoll-Rand Corporation. In 1939, the Congressional House Ways and Means Committee listed him as one of the highest-salaried men in America—at $78,000 a year. In the 1960s, the town was offered the 250-acre Westmoreland estate but turned it down, and the tract became a 150-house development of the same name. The mansion was sold to Temple Shearith Israel in the early 1970s and, today, it is still home of the reform Jewish congregation.

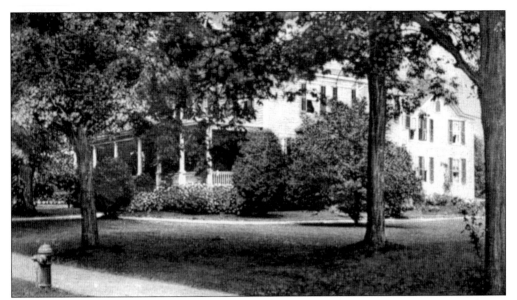

INGLESIDE, THE RESIDENCE OF GEORGE PRATT INGERSOLL. West Lane was another popular address for the wealthy in the early 20th century. The first house in from Main Street belonged to George Ingersoll, who was U.S. ambassador to Siam (Thailand) during Woodrow Wilson's administration and who once entertained the prince of Siam here. The house is now Bernard's Inn at Ridgefield (see page 75).

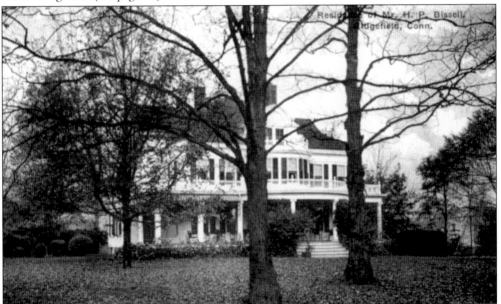

THE RESIDENCE OF H.P. BISSELL. Next door to Ingleside, and looking much the same today as it did then, is the house of Harvey P. Bissell, a town pharmacist whose Main Street store still bears his name (see page 26). A politician with connections, he held many town offices, was elected comptroller of the state of Connecticut, and later became Connecticut collector of customs. Bissell commissioned many of the postcards sold in the first half of the 20th century, including this card; one would think he might have ordered a less obscured view of his own home. For a streetscape view of the house, see page 101. The house is now the West Lane Inn.

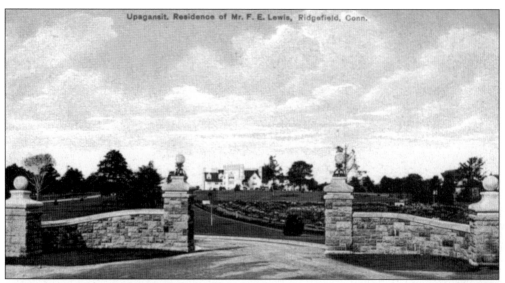

Upagansit. Residence of Mr. F. E. Lewis, Ridgefield, Conn.

"UPAGANSIT," THE RESIDENCE OF F.E. LEWIS. Upagenstit (the correct spelling) was a magnificent estate on West and Golf Lanes. Frederic E. Lewis, an express company president and financier, employed as many as 100 people to work here. His estate included a garage that could hold 15 cars, staff houses, barns, and sundry other buildings. He even provided houses for his own physician and his private chef. While most of the estate buildings are gone, the West Lane gate shown here is now the entrance to Manor Road.

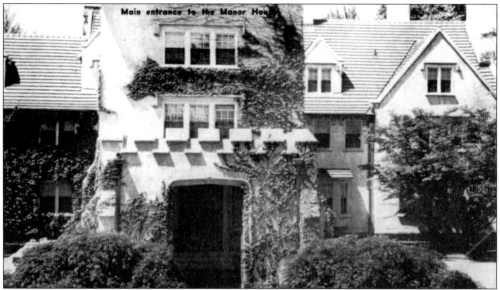

Main entrance to the Manor House

THE MAIN ENTRANCE TO THE MANOR HOUSE. Lewis's 40-room house was designed to look like an old English manor—thus the driveway leading to the house became Manor Road. In the 1930s, Eli Culbertson, a famous bridge columnist and one-time international revolutionary, acquired the place. For a couple of years in the early 1940s, it was Grey Court College (page 96 has nice views of the house-turned-college). Then, the estate had a short life as a country club and a resort in the late 1940s and early 1950s (see page 94). The house was razed in the mid-1950s, and the Ridgefield Manor Estates subdivision was created from much of the land. This card is from the resort period.

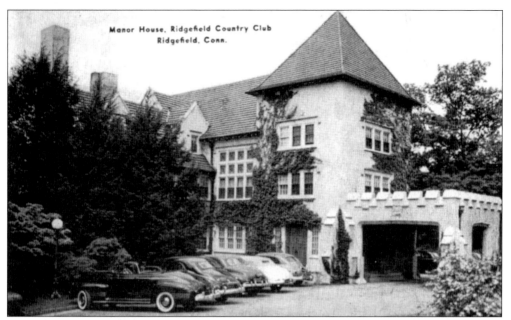

THE MANOR HOUSE, RIDGEFIELD COUNTRY CLUB. This closeup of the main entrance to the Lewis house was photographed for a late 1940s card publicizing a short-lived country club. The back of the card touts: "Ridgefield Country Club, a former 3 million dollar estate—now your vacation resort. Only 51 miles from New York City. . . ." Three million in 1950 dollars would be 22 million 2003 dollars.

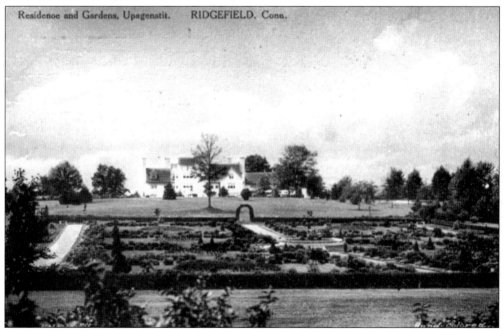

THE RESIDENCE AND GARDENS, UPAGENSTIT. With a spread like this, it comes as no surprise that Mary Russell Lewis, wife of Frederic E. Lewis, was a founder of the Ridgefield Garden Club. It is unlikely, however, that she got her hands too dirty—the estate had more than a dozen gardeners and groundskeepers under her supervision.

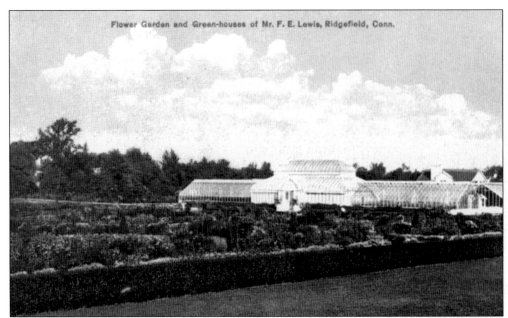

Flower Garden and Green-houses of Mr. F. E. Lewis, Ridgefield, Conn.

THE FLOWER GARDEN AND GREENHOUSE OF F.E. LEWIS. Maintaining a 70-acre estate like Upagenstit in the style to which the Lewises were—or wanted to be—accustomed meant being able to grow flowers and other plants year-round. Many flowers brightened the rooms of the manor house. The Lewises and their superintendent, John W. Smith, specialized in growing prizewinning orchids. The greenhouses were so large that not all of them fit into this picture.

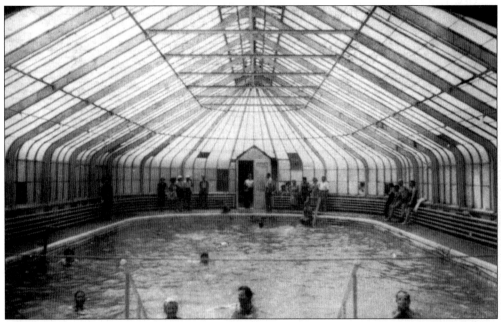

A GLASS-ENCLOSED SWIMMING POOL. The Lewises also enjoyed taking a dip year-round and had this sizable "natatorium" built near the western end of what is now Lewis Drive (the foundation is still visible in the side yard of a house). This card from c. 1950 was published by the Ridgefield Resort to advertise the fact that facilities included indoor swimming.

58

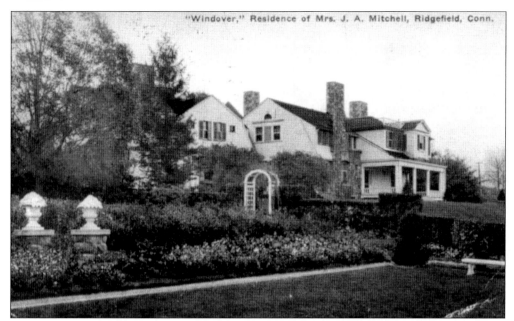

WINDOVER, THE RESIDENCE OF J.A. MITCHELL. John Ames Mitchell founded and published the original *Life* magazine, wrote a half-dozen novels, was a noted illustrator, and dabbled in the supernatural. He also gave the town the watering trough (see page 121) that now adorns the triangle at West and Olmstead Lanes, and he established the Life Fresh Air Camp in Branchville (pages 108 and 109). He died in 1918, and this card was probably published not long after that. The view is of the rear of the house, which can be seen today from South Salem Road.

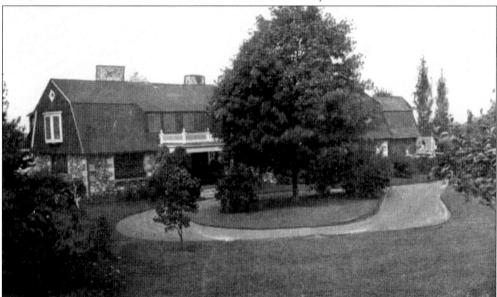

THE J.A. MITCHELL RESIDENCE. The Mitchell house faced West Lane near the schoolhouse. The same man who operates the Herald Square Hotel in what had been Mitchell's *Life* magazine headquarters in New York City bought Mitchell's house in 2001 and extensively restored it a year later. In the 1990s, he had restored the carriage house of the estate. Most of the Windover land had been subdivided in the 1970s.

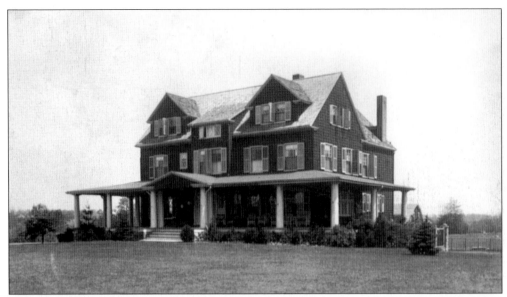

THE RESIDENCE OF MRS. L.L. DEMPSEY. Across West Lane from Windover is Northoline, a 22-room mansion built in 1901 by Lillian Loomis Dempsey. This real-photo image probably dates from soon after the place was built in an old field—note how much the vegetation has grown by the time of the view below. The house is still there today but obscured by even more trees and shrubs.

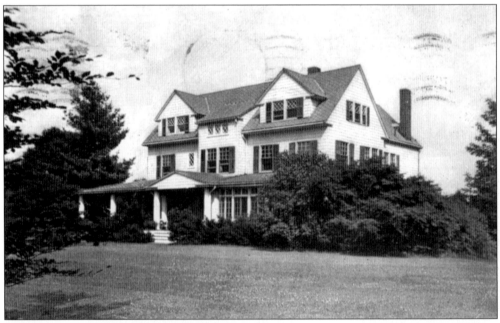

THE HOME OF GERALDINE FARRAR. In 1924, Metropolitan Opera star Geraldine Farrar bought Northoline, renaming it Fairhaven. Geraldine Farrar was the daughter of 1880s Philadelphia Phillies first baseman Sidney Farrar, who had a farm on North Salem Road. She retired from opera in 1931 but not from an active life in Ridgefield, where she belonged to many service organizations, including Red Cross and Girl Scouts. In 1954, she moved to New Street, where she died in 1967.

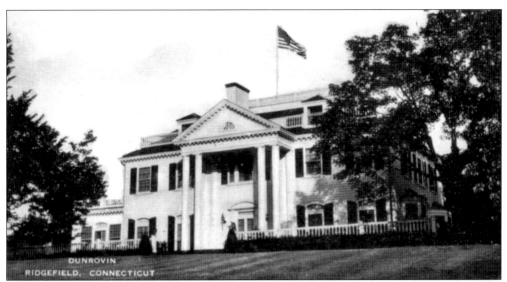

DUNROVIN. In the 1890s, Melbert B. Cary, a prominent New York City attorney, built Dunrovin, then called Wildflower Farm, on West Lane opposite Cedar Lane. Cary was head of the Connecticut Democratic party from 1898 until 1902, when he ran—unsuccessfully—for governor. He also wrote several books on political subjects. William Mattheus Sullivan, attorney for the Metropolitan Opera and some of its stars, later owned the estate. He maintained a private playhouse on the grounds, where such stars as Lily Pons, Grace Moore, and Lawrence Tibbett performed. The house passed into other hands, and one Sunday in the 1970s, the owners cleared still-hot ashes from a fireplace, put them on a wooden porch, and went to New York. The ashes ignited the wood, and Dunrovin burned to the ground.

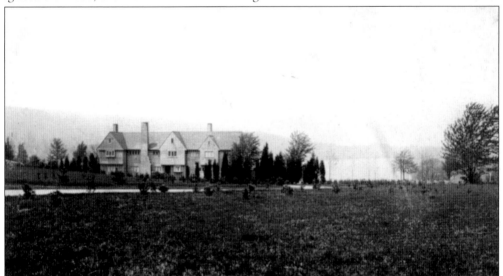

THE RESIDENCE OF H. DE B. SCHENCK. Henry Schenck's mansion at Lake Mamanasco (barely visible in the background) is still standing today, but you would have a hard time seeing it from this spot because of all the trees and houses that now stand around the property off Tackora Trail. Like so many others who established estates here, Henry Schenck built the place, called Nydeggen, on what had been farmers' fields. Even earlier, this spot at the south end of the lake was believed to have been an American Indian village. The house has a twin nearby—see pages 78 and 79.

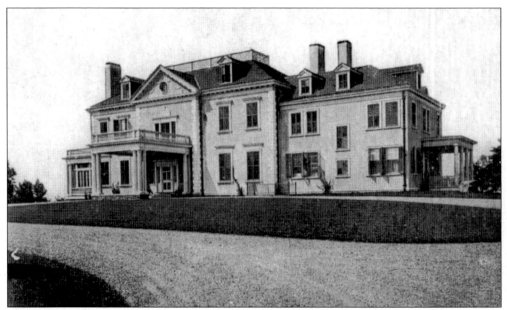

THE RESIDENCE OF JAMES STOKES. High up on West Mountain, nearly 1,000 feet above sea level, stands Sunset Hall, the stately mansion of James G. Phelps Stokes, a political scientist, U.S. ambassador, and humanitarian. From the widow's walk, on the roof, one can see the skyline of New York City, 50 miles away. The estate included much of the shoreline of Round Pond, which was the reservoir for the Ridgefield Water Supply Company.

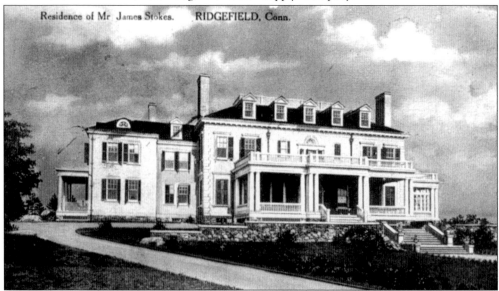

Residence of Mr. James Stokes. RIDGEFIELD, Conn.

THE RESIDENCE OF JAMES STOKES, REAR VIEW. This is the back of Sunset Hall, which faces the west, overlooking the pond. Later owners of the place included Dr. L.D. Weiss, a brother of Houdini, the magician; the St. Vincent DePaul congregation, which ran a novitiate in the building; and Robert Vaughn, the movie and television actor. In 1946, the estate was one of the places under consideration as the site of the United Nations headquarters. In early 1950s, International Business Machines (IBM) eyed it as the location for a corporate country club, but local zoning did not allow it.

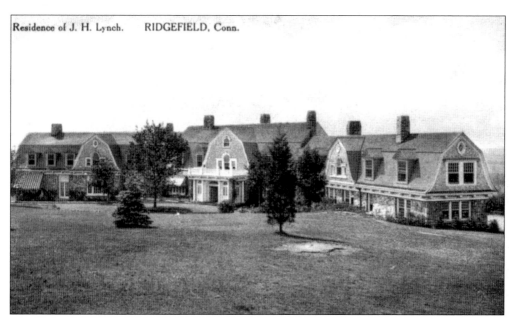

Residence of J. H. Lynch. RIDGEFIELD, Conn.

THE RESIDENCE OF J.H. LYNCH. John H. Lynch built this sprawling home on 50 acres at the top of West Mountain Road in 1906. The place remained in the Lynch family until 1962, when it was sold to the Congregation of Notre Dame, who made it the U.S. mother house for the order of nuns based in Montreal. Today, it is a center for retired members of the congregation.

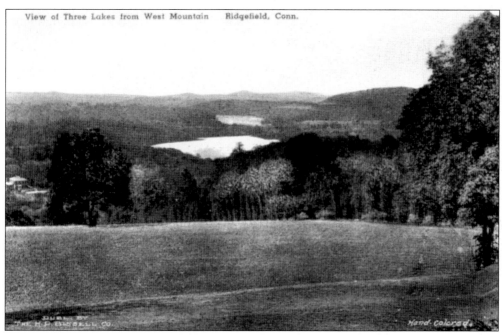

View of Three Lakes from West Mountain Ridgefield, Conn.

A VIEW OF THREE LAKES FROM WEST MOUNTAIN. John Lynch clearly selected his home site with the view in mind. From the rear of his house he could look out over nearby Lewisboro, New York, and its Lakes Oscaleta, Rippowam, and Truesdale and could even see the Hudson River Valley far beyond.

OUTPOST FARM
Residence of Col. L. D. Conley
Ridgefield, Conn.

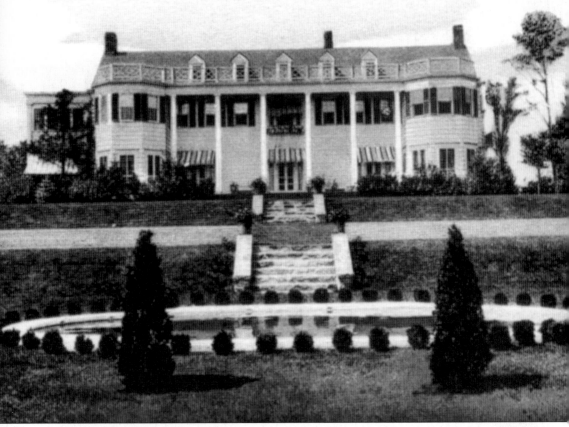

OUTPOST FARM, THE RESIDENCE OF COL. L.D. CONLEY. The majestic home of Col. Louis D. Conley was at the center of an estate that had more effect on Ridgefield than any other. Conley, a tinfoil manufacturer who had headed the Fighting 69th Regiment, retired to Ridgefield in 1914 and, by 1922, owned more than 1,500 acres. Most of the land was devoted to Outpost Nurseries, which provided trees and shrubs to cities, estates, corporations, and even the 1939 World's Fair. Conley's land extended along both sides of Route 7 down to Stonehenge and along Route 35 to Copps Hill. Outpost Inn (see pages 69 to 74), now Fox Hill condominiums, was part of the family holdings, and the Conley kennels became Gaines laboratories and then a restaurant (page 113). Countless trees that were part of the nursery remain today in subdivisions and open spaces, and many roads in the area are named after species grown nearby by Outpost. The house here became Fox Hill Inn in the 1940s, but in 1971, the house and more than 700 acres were sold to IBM, which planned, without success, to put a corporate school there. IBM tore down the house in 1974. In 2001, the town acquired 458 acres around and north of the house site as open space, called Bennett's Pond. A year later the town sold the land to the state to become part of the Wooster Mountain State Park. For a look behind the front façade, see page 78.

Four
GRAND OLD INNS
AND RESORTS

*Fine dining and superb accommodations helped make Ridgefield a popular
destination in the first half of the 20th century.*

THE OLD KEELER TAVERN. Ridgefield's first inn was probably the Keeler Tavern. Built as a
house *c.* 1714, the place became Timothy Keeler's tavern and inn in 1772. Five years later, the
British fired a cannonball into its side, and the relic of the Battle of Ridgefield is still visible
today. The tavern, also a post office, was a stop on the northern Post Road between New York
and Hartford.

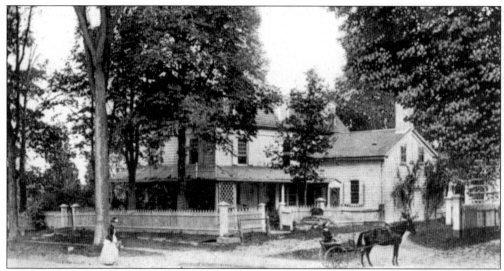

THE OLD KEELER TAVERN. While this card was published *c.* 1905, the photograph probably dates from the 1880s or 1890s, when the tavern was Abijah Ressiguie's hotel. In 1907, architect Cass Gilbert bought the place as his country home (see pages 11 and 12). In 1966, the Keeler Tavern Preservation Society acquired the property, turning the tavern into a historical museum.

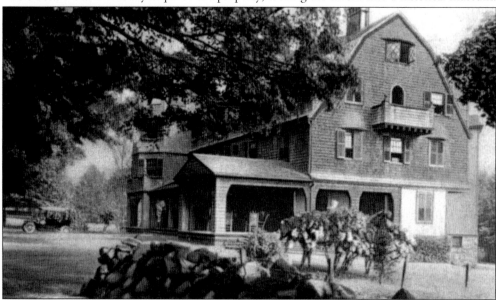

THE RIDGEFIELD INN. On the east side of the south end of Main Street stood the Ridgefield Inn, a four-story building that, between 1907 and 1911, served a double function. In the summer, it was an inn; the rest of the year, the building housed the Ridgefield School, a private boys' preparatory school, which in 1911 moved to its own campus on North Salem Road (see pages 94 and 95). For many years Elizabeth Chase Bacon operated the inn. Her daughter, Peggy Bacon, was born there in 1895 and went on to become a prominent American author–illustrator, producing more than 60 books—many for children, but including highly praised mysteries for adults. Her artwork is in the collections of the Metropolitan Museum of Art in New York and the National Gallery of Art in Washington. She died in 1987 in Maine. The inn was razed *c.* 1925, and a modern house stands on the site today.

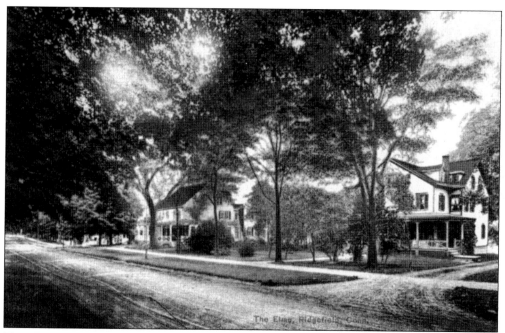

THE ELMS, c. 1910. The Elms Inn complex is shown *c.* 1910 in this German litho card. The original inn and restaurant is at the left, and the more modern accommodations building is at the right. The old inn dates back to 1799 and, over the years, has had only a handful of proprietors. The Scala family, owner in 2003, has operated the inn for more than a half-century.

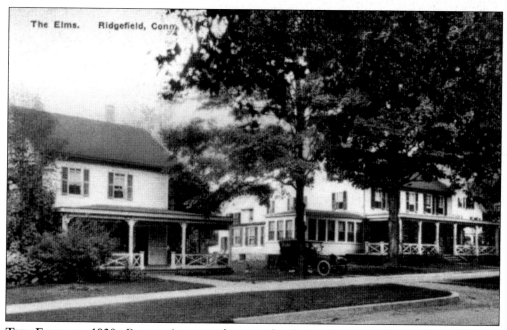

THE ELMS, c. 1920. Because it was such a popular destination, more than a dozen different postcard views of the Elms were published over the years (for some others, see pages 4 and 17). This view shows the small northern house, used for many years to house family members but now a set of suites.

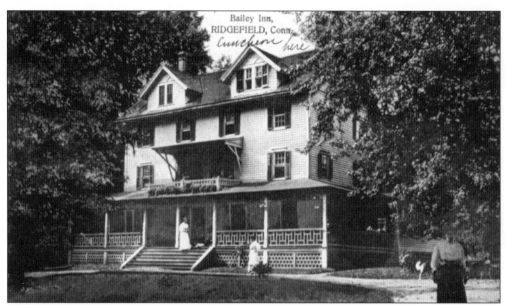

BAILEY INN, 1909. Still another popular Main Street hostelry was Lewis H. Bailey's four-story inn, which stood on the west side of Main Street about opposite the First Church of Christ, Scientist. Before the Civil War, the building was a candlestick factory, and its second floor later became a popular meeting place called Tammany Hall. Later, the building was a tenement house until Lewis Bailey turned it into a fancy inn. This view, dated 1909 on the front, shows several women apparently going for a stroll along Main Street.

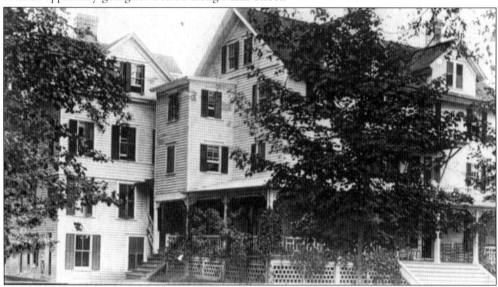

BAILEY INN. In the previous postcard, the large rear wing of the inn, shown here, is hidden. The inn was demolished in 1919, but the wing was moved next door to the rear of the King mansion, where it still stands today (see page 47). Pharmacist George A. Mignerey used this real-photo card to order printed cards from a publisher. On the back are the instructions for coloring and sizing the card, including "bld white, dark shingle roof, make full-faced card." A full-faced card did not have a white border, as many old cards did. (The author has never seen the printed card produced from this original.)

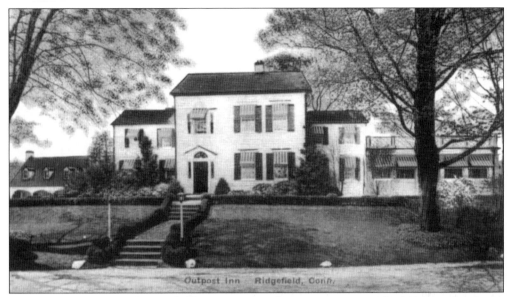

OUTPOST INN. None of Ridgefield's many inns and resorts ever approached Outpost Inn in the number and variety of postcards commissioned in its behalf. (The author's collection includes more than 20 different views of the place, published between the inn's establishment in 1928 and its demise in the early 1960s.) The main building, shown here, was based on an 1816 house, built by Albin Jennings for his bride. Jennings, from Weston, had come here in 1812 to build a nearby house and fell in love with Polly Dauchy, daughter of the man who hired him.

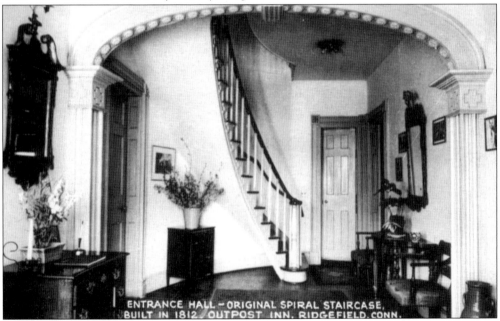

THE ENTRANCE HALL AND ORIGINAL SPIRAL STAIRCASE. The elegant entrance hall and stairs in his home demonstrate Albin Jennings's skill as a carpenter. The Outpost Inn owners were clearly proud of the room, for many copies of this card were produced in both horizontal and vertical versions. It is one of the very few views of the inside of an old Ridgefield house ever reproduced on a postcard.

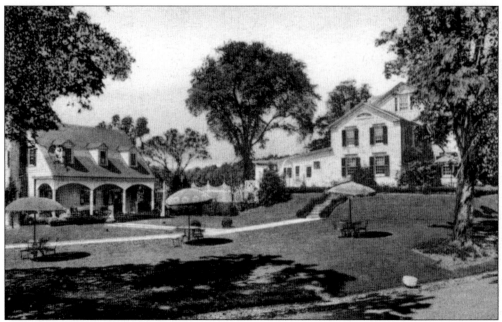

HEARTHSTONE OUTPOST INN. When Col. Louis D. Conley purchased the old Jennings spread, he and his family added and modified buildings to make it an attractive inn. This view shows the north side of the main inn (right) and a guesthouse. For a while after the Conley family sold its interest in the property, the inn was operated by the Hearthstone Corporation, which owned several New York City restaurants and which called the inn Hearthstone Outpost Inn. Outpost Pond is behind the buildings.

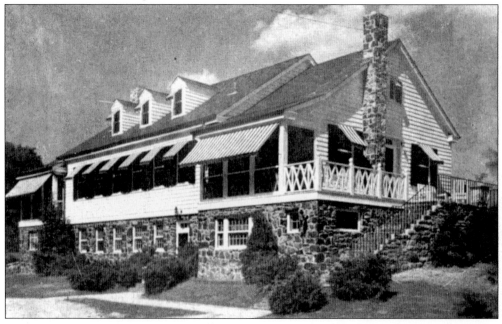

THE GUESTHOUSE, OUTPOST INN. The guesthouse north of the inn is shown in this early-1940s view. The windows here overlook the pond. From the 1930s to the 1950s, many stage and screen stars came to Outpost to escape for a few days.

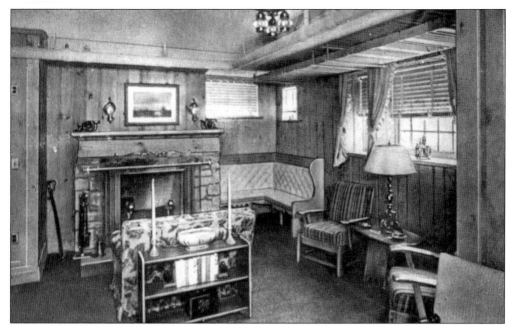

THE READING ROOM, OUTPOST GUESTHOUSE. In the postcards they commissioned, the inn managers wanted to display the comfortable features of Outpost. This view shows the knotty-pine-paneled room where one could go to read a book or newspaper, with a fire in the fireplace, if needed.

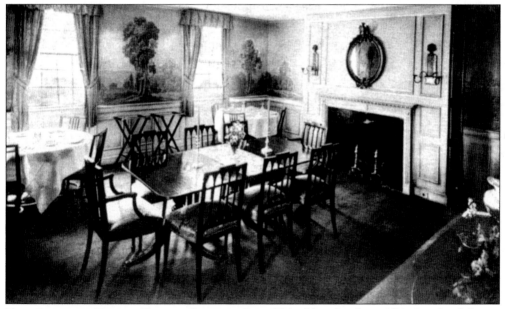

THE COLONIAL DINING ROOM, OUTPOST INN. The old parlor from Albin Jennings's house became one of several dining rooms at Outpost. The room was decorated with fine antiques and murals that reflected the Outpost Nurseries theme.

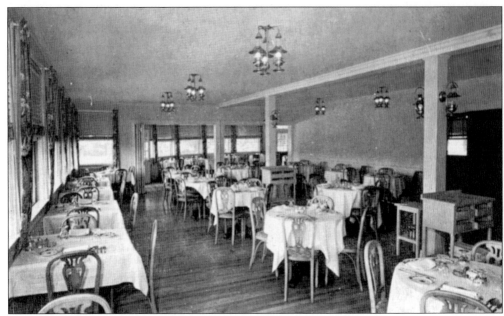

THE MAIN DINING ROOM, OUTPOST INN. Most people ate in the main dining room, whose windows looked out over Outpost Pond and Danbury Road. *Gourmet* magazine once listed Outpost Inn as one of the 10 best restaurants in the United States.

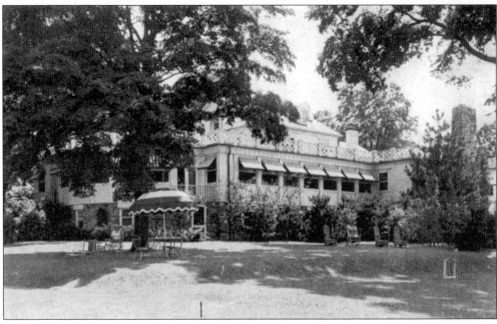

OUTPOST INN. The main dining room of the inn is shown from the outside in this view. The awninged windows shown here are the ones along the wall at the extreme left of the previous image.

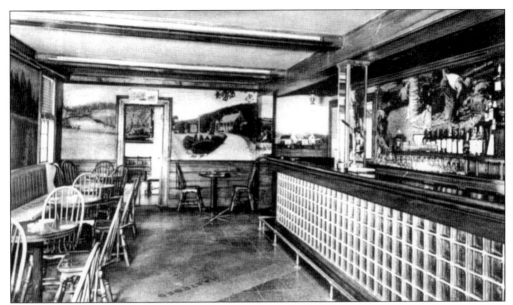

THE COCKTAIL LOUNGE AND BAR, OUTPOST INN. The bar at the inn was a popular stop for Ridgefielders as well as tourists. The walls bore murals of various Outpost Nurseries scenes—the image of the building depicted on the far wall is identical to the image used in the postcard on page 112. At the right behind the bar, a picture shows Outpost Nurseries workmen planting the huge balled roots of a live tree. Even the floor was an illustration: a map of Connecticut.

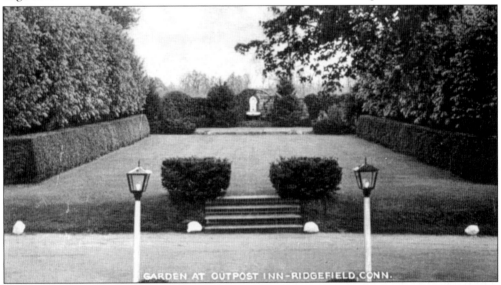

A GARDEN AT OUTPOST INN. Outpost Inn included 27 acres, some of it landscaped into handsome gardens. After the inn closed, the complex became a small private school owned by Carl Shapley, son of famous Harvard astronomer Harlow Shapley. The school lasted only a couple of years, and David Paul, who was developing Casagmo apartments on Main Street, acquired the property at auction in 1969. Soon after that, the main inn was heavily damaged in a suspicious fire. Paul built 286 units on the property, including Ridgefield's first condominiums. The place is called Fox Hill, after the inn that operated in Col. Lewis D. Conley's former home (pages 64 and 78).

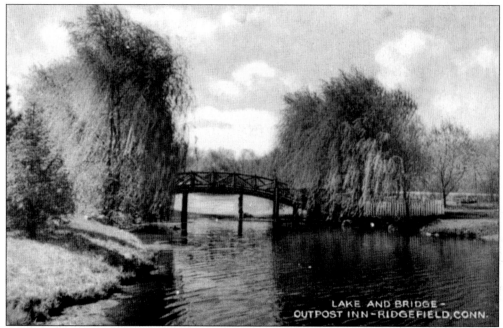

LAKE AND BRIDGE –
OUTPOST INN – RIDGEFIELD, CONN.

The Lake and the Bridge, Outpost Inn. In the 1920s, Col. Lewis D. Conley had a swamp along Danbury Road dug out to make Outpost Pond and in the process created an island. On the island he kept a swan house and had one of his caretakers feed the swans each day. In winter, the caretaker would bring along an axe to chop away enough pond ice so the swans could take a swim. Another view of the pond appears on page 97.

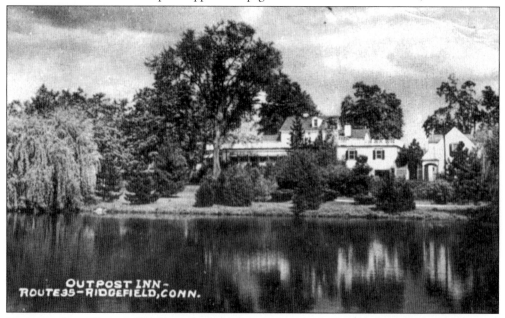

OUTPOST INN –
ROUTE 35 – RIDGEFIELD, CONN.

Outpost Inn, Route 35. From Danbury Road passersby looked across Outpost Pond to see the inn. For many years the pond was a popular place for the town's children and adults to go ice-skating. When the condominiums were built, worries about liabilities brought public skating to an end.

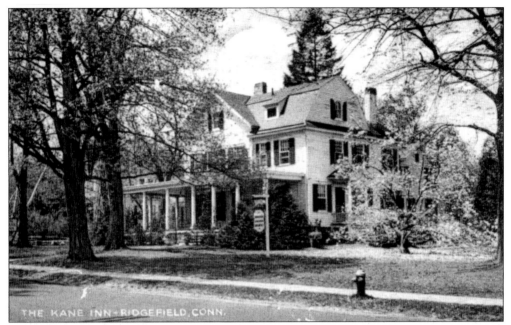

THE KANE INN. In the 1930s, the former home of George Pratt Ingersoll (page 55) was acquired by Chris and Page Kane, who turned it into the Kane Inn, providing both food and lodging. Page Kane had taught in the New York City schools and was an expert pianist who performed at many Ridgefield functions and played the organ for several Ridgefield churches. Later, Walter Tode took over the operation, calling it the Inn at Ridgefield (although most locals called it Tode's). This card was postmarked in 1942.

THE INN AT RIDGEFIELD. Walter Tode made some changes in the building, including adding the open deck at the left and the awning—which was later extended all the way to the sidewalk. Later, as the inn became more and more popular with New York City and local diners, the porches were all converted to dining room spaces. Today, the place is called Bernard's Inn at Ridgefield, an acclaimed restaurant that no longer offers lodging.

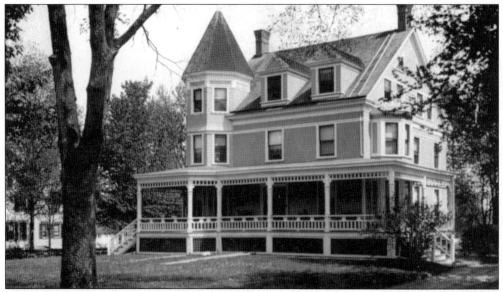

WEST LANE INN. Back in 1910, this elegant Victorian on the south side of West Lane served as yet another inn. However, not long afterward, the owner apparently decided that apartments were less of a hassle than was innkeeping, and for most of the 20th century, the place was known as the Bluebird Apartments. The building, still an apartment house, is virtually the same today except that the porch staircase is in the front. Directly across the street, in the old Bissell house (pages 55 and 101), is the current West Lane Inn.

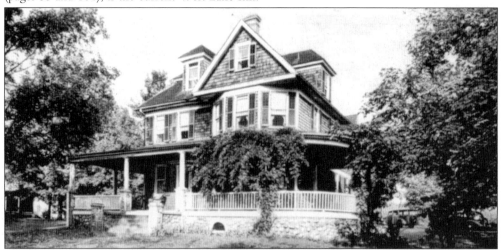

LA BRETAGNE INN. At the corner of West and Olmstead Lanes stood La Bretagne Inn. The inn was originally a house that Frederic E. Lewis, owner of the Upagenstit estate, across West Lane, purchased for his personal physician (page 56). In the 1940s, Eloise Lindsay established La Bretagne Inn there. "An hour's drive from New York you will find a Brittany atmosphere where your favorite French dish will be served at reasonable price," says the back of the card. "Order in advance." In 1947, an early-morning fire heavily damaged the building and helped prompt town fathers to establish a paid fire department with at least one man on duty around the clock. The fire department grew and public safety improved, but the lot of La Bretagne did not fare as well. In 1960, another fire broke out at the inn, this time destroying it. In its place stand three small two-family houses.

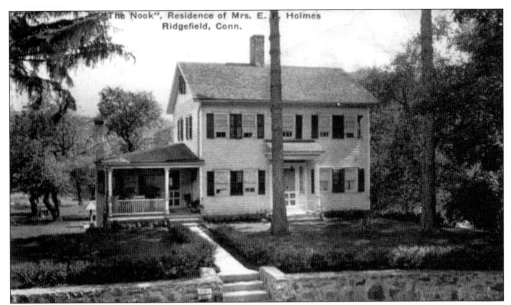

THE NOOK, THE RESIDENCE OF MRS. E.F. HOLMES. On Stonehenge Road, then the old Route 7, stood the early-19th-century house and antiques dealership of Lydia Holmes, shown in this 1930s card. In 1946, Victor Gilbert, back from serving in World War II, bought the house and established Stonehenge Inn, which quickly gained an international reputation as a restaurant and country retreat. Many movie stars, statesmen, and other leaders—including even Emperor Haile Selassie of Ethiopia—dined or stayed at Stonehenge.

"STONEHENGE, VICTOR GILBERT, SKINKER." This postcard, based on a 1946 drawing by Burt Sullivan, shows the original Stonehenge Inn, expanded somewhat from the days of Lydia Holmes. Victor Gilbert, a well-known character in town, later moved to the Virgin Islands. Skinker, incidentally, is a fancy word for a bartender. Albert Stockli, the Swiss-born chef who created the Four Seasons, the Mermaid Tavern, and other famous New York City restaurants, took over in 1965 and gave the inn an even better reputation. His book *Splendid Fare* (1970) is still well respected today. Stockli died in 1972 at the age of 54. In 1988, fire destroyed the 170-year-old inn but not the business. The main building was rebuilt and Stonehenge still thrives today.

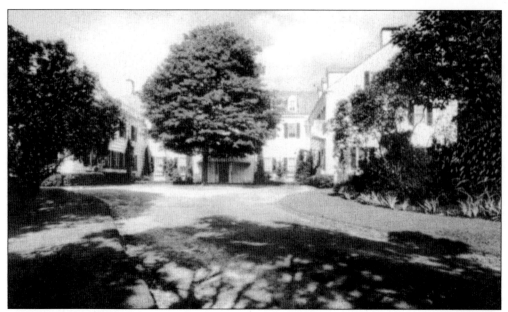

FOX HILL INN, ROUTE 7. Fox Hill Inn, a good half-mile from Route 7, was shown from the front in many postcards, such as the picture on page 64 when the mansion was Col. Louis D. Conley's home. This card from the late 1940s shows that behind the main building were two huge wings. John Yervant operated Fox Hill Inn for many years. Born Yervant Kouyoumjian in Armenia before World War I, John Yervant survived deportations and massacres under Ottoman rule and came to America. He and his wife, Felice, became a noted dance team before turning to innkeeping. His autobiography, *Needle, Thread and Button,* was published in 1988.

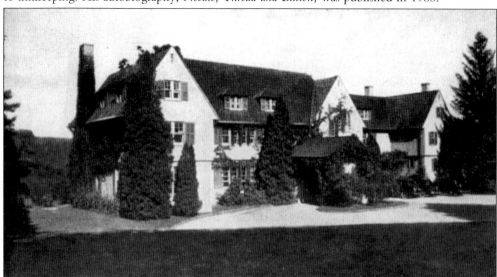

MAMANASCO LAKE LODGE. "A beautiful country estate converted into a vacation paradise" is how this 1940s postcard described Mamanasco Lake Lodge. The handsome mansion stands at the south end of Lake Mamanasco, on Tackora Trail near North Salem Road. Since the 1960s, it has served as a retreat house, first for Jesuits, who called it Manresa, and later for the traditionalist Society of St. Pius X, who operate St. Ignatius Retreat House there. Built early in the 20th century, the 27-room house is the near twin of Henry Schenck's Nydeggen, shown on page 61.

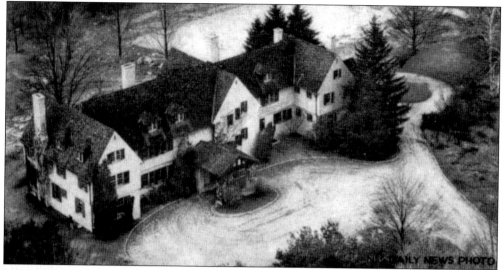

MAMANASCO LAKE LODGE. Why would the New York Daily News go to the expense of taking an aerial photograph of a Ridgefield house in 1940? Because it was then the country home of George Scalise, a New York City racketeer who was indicted that year by crusading district attorney (and later presidential candidate) Thomas E. Dewey for extorting hotels and contracting firms out of what would be more than $1.2 million today. George Scalise had been exposed by another crusader, newspaper and radio columnist Westbrook Pegler, who later moved here. Pegler was one of a half-dozen Ridgefielders who have won a Pulitzer Prize; his was for his Scalise exposé. The subsequent owners of the house, who turned the place into a resort, had evidently seen the *Daily News* photograph and got the newspaper's permission to use it on this postcard.

A VIEW OF THE LAKE FROM THE GROVE, MAMANASCO LAKE LODGE. This early-1940s view from the south end of the lake, looking northwestward, shows lodge patrons enjoying the water. The enclosed area was probably for small children. Out in the lake is the "grassy island," still there today, but smaller. The hillside was all woods then; with the development of Eight Lakes Estates (next page) in the 1950s, hundreds of houses were built along the lake and on the hillside. However, so many trees remain that the scene today is not much different from this predevelopment view. The building off in the distance was probably part of Peatt's Resort, where visitors could stay in cottages. The note on this card says: "Do you wish you were here? It's lovely, quiet and restful, and exactly what we want." The writer's view was probably frozen; the card was mailed in February 1946.

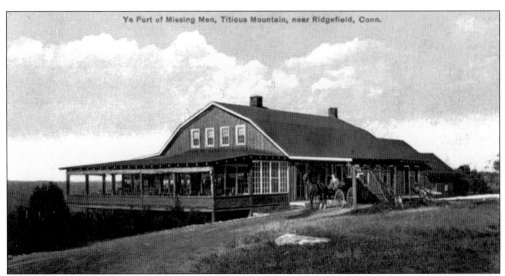

YE PORT OF MISSING MEN, TITICUS MOUNTAIN, NEAR RIDGEFIELD. Although it may look like little more than an old barn, the Port of Missing Men was a popular destination at the center of a huge tract of land. Ridgefielder H.B. Anderson collected some 1,800 acres early in the 20th century and hired Italian immigrants to build 10 miles of road and several ponds (see page 104), as well as this restaurant with a spectacular view that stretched to the far side of the Hudson River, 20 miles away. The operation, named for a contemporary novel, opened in 1907 and attracted city-dwellers who wanted a fine place to eat, along with a taste of the "wilderness." In the first two years of operation, more than 20,000 people signed the guest book for the restaurant, whose specialty was country-style chicken, either fricassee or broiled.

YE PORT OF MISSING MEN, TEA HOUSE. The restaurant was called the Tea House, though undoubtedly before Prohibition arrived in 1920, beverages stronger than tea were consumed. This pre–World War I card offers a view of the array of old cars belonging to patrons. The Tea House was on the extension of Old Sib Road just across the state line in North Salem, New York. In the 1950s, developers subdivided 600 acres of Ye Port of Missing Men land in Ridgefield into the Eight Lakes Estates, where hundreds of homes were built. In New York State, most of the Port land was acquired by Westchester County and is now Mountain Lakes Park. The restaurant closed in the 1930s.

Five

OLD-TIME RELIGION

In the early 20th century, only five church buildings—two Congregational, one Episcopal, one Methodist, and one Catholic—served the religious needs of Ridgefielders.

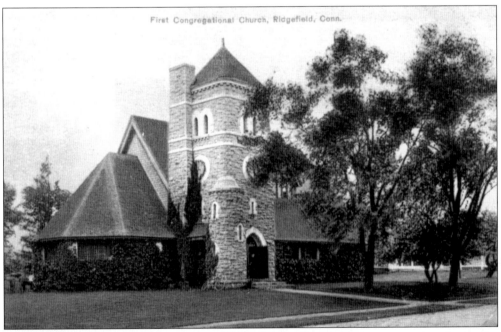

First Congregational Church, Ridgefield, Conn.

THE FIRST CONGREGATIONAL CHURCH. Ridgefield's oldest religious congregation also has the village's oldest church. The First Congregational Church was established shortly after the town's settlement in 1708 and went through several traditional New England–style wooden buildings before this stone Romanesque Revival edifice was erected in 1888. The architect was Josiah Cleveland Cady (1837–1919), who designed buildings at Yale and Columbia and who had summered here. His brother (page 10) lived right across Main Street from the church. Cady designed the building after a small church he had seen on a trip to Italy. He was a student of Henry Hobson Richardson, who designed the famous Trinity Church in Copley Square, Boston. This view is from *c.* 1910.

CASS GILBERT FOUNTAIN AND THE CONGREGATIONAL CHURCH. This view from the 1940s shows much that is and is not there now. The mailbox is long gone and so is the fire hydrant in the fountain island, just left of the tree. The tree, too, long ago died. The small, many-windowed building at the extreme left was a model, built on wheels so it could be drawn in parades, which depicted the previous Congregational church that stood on the Ridgefield Green. By the 1970s, the model was sitting outside Daybreak Nursery in Westport. What happened to it after that is unclear. This picture also shows the old church house wing. In 1978, a child playing with a candle led to a fire that destroyed the wing, replaced with Lund Hall two years later.

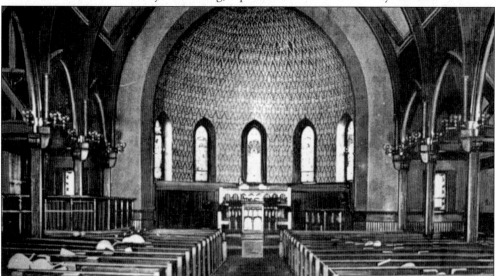

THE CONGREGATIONAL CHURCH, INTERIOR VIEW. The inside of the First Congregational Church *c.* 1910 is shown on this hand-colored card. Those are probably oil lamps on the chandelier and along the walls. While it has the oldest congregation, formed in 1712, First Congregational does not have the oldest church in town. However, no postcards depicting the Ridgebury Congregational Church's building, erected in 1851, have been found. Few if any Ridgebury cards were published because the northern section of town was "off the beaten path" and apparently did not attract tourists.

ST. STEPHEN'S EPISCOPAL CHURCH. St. Stephen's, the second oldest religious congregation in Ridgefield, was formed in 1725. This is the third of four houses of worship used by the parish on this site. This wooden structure, shown *c.* 1905, was razed in 1914 to make way for the new stone church (page 84) completed a year later. At the left in this picture is the congregation's South Hall, then a private residence.

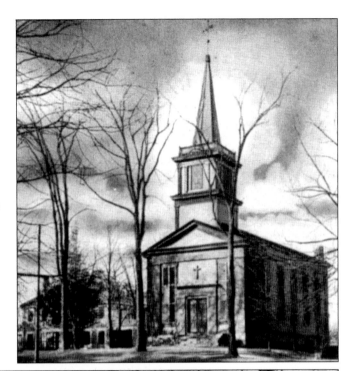

ST. STEPHEN'S EPISCOPAL CHURCH AND RECTORY. This view, also from *c.* 1905, shows the hip-roofed rectory, which *c.* 1915 was sold and moved to Catoonah Street, about opposite the firehouse, where it serves today as shops and offices. The first Episcopal church building closed during the Revolution and was used by patriots to store war supplies. During the Battle of Ridgefield, the British burned the building. A new one was built after the war, only to be replaced in 1841 with the structure shown here. At the far right is a village business building; just to the left of it is an empty lot on which North Hall was built in 1909. Ten years earlier, the Ridgefield Library offered to buy the empty lot from St. Stephen's in order to erect its new building there. The church declined, and the library built at Main and Prospect Streets instead.

St Stephen's Parish Buildings,
Ridgefield, Conn.

ST. STEPHEN'S PARISH BUILDINGS. This early view from the middle of Governor Street shows the old church, the rectory, and at the right, North Hall, when it was called the parish house.

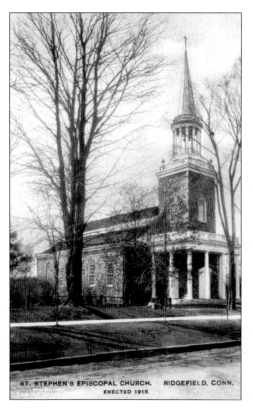

ST. STEPHEN'S EPISCOPAL CHURCH. RIDGEFIELD, CONN.
ERECTED 1915.

ST. STEPHEN'S EPISCOPAL CHURCH, ERECTED IN 1915. Few vertical postcards of Ridgefield scenes were ever published, and almost none of them were of churches except for several different cards of St. Stephen's. That was probably because until the new Methodist church was built in 1966, St. Stephen's had the tallest spire. It is still the most vertical-looking church in town. Notice the south wall of the church; a ladder is leaning up against the stone, suggesting the building may still have been under construction when this picture was taken. Nonetheless, it seems strange that no one bothered to lower the ladder to the ground so that it would not appear in the postcard portrait.

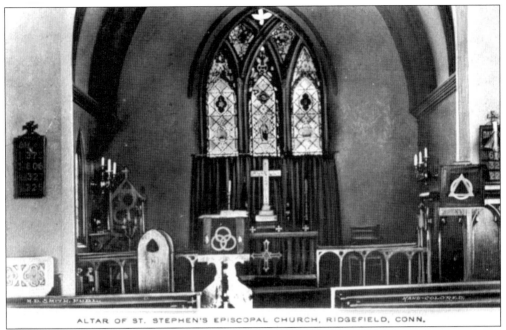

ALTAR OF ST. STEPHEN'S EPISCOPAL CHURCH, RIDGEFIELD, CONN.

THE ALTAR AND INTERIOR OF ST. STEPHEN'S. These two postcards show the change in the altar and sacristy design between the previous (above) and current (below) church buildings. However, the lower view is from *c.* 1920 and thus is not exactly modern. At least one fixture stands out as having been transferred from one church to the next: the altar cross, which was an 1895 gift from the church school. The cross is still used today.

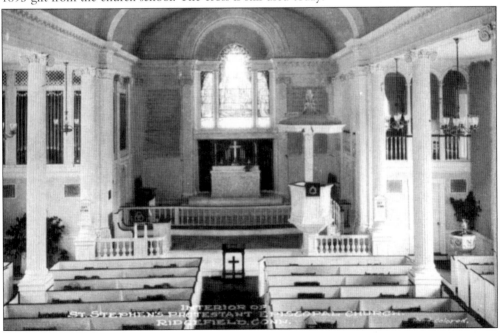

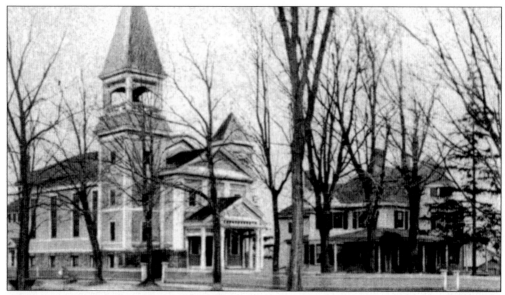

JESSE LEE MEMORIAL UNITED METHODIST EPISCOPAL CHURCH. Built in 1841, the Methodist church was a handsome landmark at the corner of Main and Catoonah Streets. The church was named for a famous Methodist preacher and missionary who spoke here in 1789, helping to establish Ridgefield's congregation. This was the congregation's second church; the first stood at the corner of North Salem Road and North Street—land now part of a cemetery. The church was razed in 1964 to make way for the commercial building that is currently there; the rectory at right still stands, today holding shops and offices.

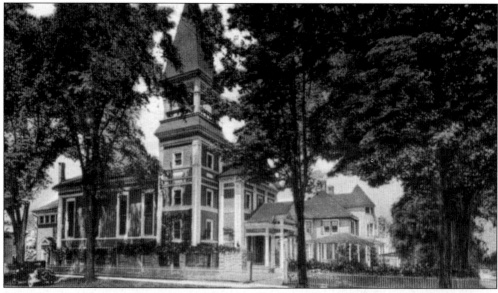

JESSE LEE METHODIST CHURCH. This hand-colored card beautifully shows what a handsome pair of buildings the Methodist complex was. By the 1950s, however, the congregation had grown to the point where the church was too small to meet its needs and parking was a growing problem. In 1958, the Methodists bought the Freund estate on Main Street and began plans to build a church there, selling this in 1964 to cover construction expenses. When the church was torn down, the appearance of the center of town changed forever. (See also page 121.)

THE METHODIST EPISCOPAL CHURCH AND PARSONAGE. This card, postmarked 1911, shows the Methodist buildings from a different angle. The picket fence along Main and Catoonah Streets was part of the distinctive look of the Methodist property. The late Karl S. Nash, Ridgefield Press publisher, reported that the fence contained 1,063 pickets. Odds are, he had counted them himself.

JESSE LEE MEMORIAL METHODIST CHURCH. This view of the interior of the old church shows the pipe organ in an alcove left of the altar. Charles Wade Walker, owner of Walker's Happy Shop (page 33), was the church organist for decades. The design of the interior was simple and spare, the least ornate of the village's four churches.

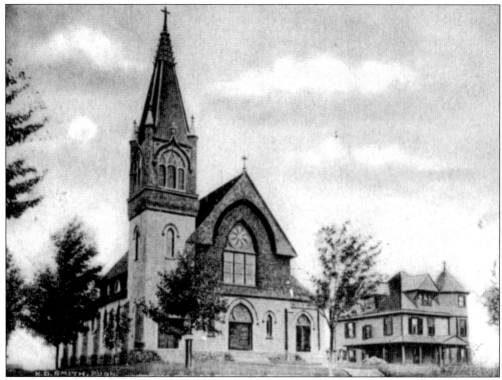

ST. MARY'S CHURCH AND PAROCHIAL RESIDENCE. Two views from the start of the 20th century show St. Mary's Church and rectory from different angles. The Ridgefield Preservation Trust has called the Victorian Gothic church, built in 1896, "one of Ridgefield's finest buildings . . . a complex and disciplined design, which reflects the idealistic romantic approach to architecture of the Victorian age." A pastor in the 1970s decided the rectory was unnecessary, razed the building, and moved the priests to apartments in St. Mary's School, which had closed. The land is still vacant today.

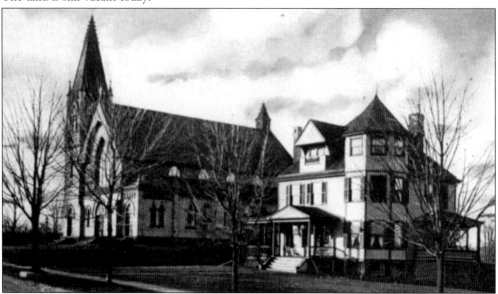

ST. MARY'S CHURCH, INTERIOR VIEW. This hand-colored view from the choir loft shows the church *c.* 1915. St. Mary's first church, built in 1879, was much more modest in size and could not long hold its growing congregation. It is now the Ridgefield Thrift Shop building on Catoonah Street, across from the firehouse.

ST. MARY'S CLUB. Erected in 1907, St. Mary's clubhouse served the social and classroom needs of the parish for many years. The Knights of Columbus bought it in the 1970s, but at the beginning of the 21st century, the parish bought it back. In 2002, it was renovated to serve as church offices that had moved out of the resurrected and expanding St. Mary's School. The picture is so crisp that you can clearly see a man in a straw hat and a child sitting in the car (left). High Ridge is at the right side of the card, with Catoonah Street in the foreground.

THE NOVITIATE, HOLY GHOST FATHERS. When many of Ridgefield's mansions and estates grew uneconomical to own as private homes, some became attractive for a new use: religious centers, almost all of them Catholic. Among the congregations that have had operations in old mansions here were the St. Vincent de Paul Fathers novitiate (page 62), the Congregation of Notre Dame mother house (page 63), and the Jesuit retreat house, Manresa, which later became the Society of St. Pius X retreat house (pages 78 and 79). Of all the congregations, none was here longer than the Holy Ghost Fathers, who in 1922 established a novitiate—a school for men called novices who were studying for the priesthood—in the main house of the old Cheesman estate on Prospect Ridge. Many became missionaries who went off to stations all over the world. A close look reveals a dozen novices and priests standing on the porch and stairs. In the late 1960s, the Holy Ghost Fathers closed the facility, and in 1971, the town bought it, using the house and a three-story wing that the fathers had built as a headquarters for the Ridgefield Board of Education. In the late 1980s, with the addition of another wing, it was converted to congregate housing for the elderly. Outbuildings on the old estate now serve the Ridgefield Theater Barn, the Ridgefield Guild of Artists, and the Marine Corps League. Land is used for affordable apartments, athletic fields, community gardens, and the Bark Park—a public playground for dogs.

Six
EDUCATION, PUBLIC
AND PRIVATE

From one-room schoolhouses to a college campus, Ridgefield has had dozens of schools,
but only a few have made it to postcard fame.

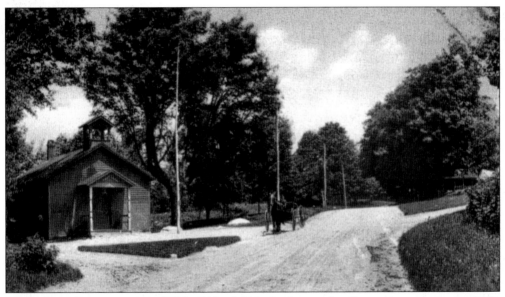

WEST LANE SCHOOLHOUSE. While Ridgefield had a dozen schoolhouses in operation by 1910, West Lane's "Little Red Schoolhouse" appears to be the only one to be recorded on a postcard. That is probably because it stood along the main entrance to town—West Lane and South Salem Road, today's Route 35—from the New York City region. Consequently tourists often saw the picturesque building. Perhaps, too, its red paint made it attractive to postcard publishers; most schoolhouses weren't so colorful. The school has also been called the Peter Parley Schoolhouse, recalling the pen name of Samuel G. Goodrich, born nearby in 1793 (see page 53). Goodrich attended this school and describes the experience in *Recollections of a Lifetime* (1856). During the warmer months, the Ridgefield Garden Club opens the schoolhouse to the public one Sunday afternoon a month.

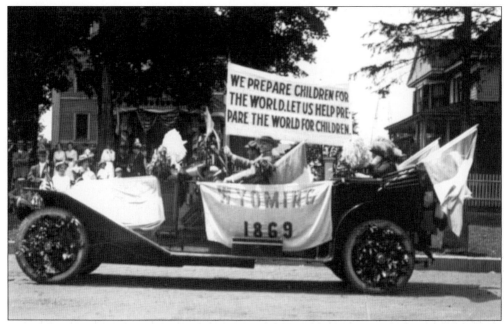

THE NEW SCHOOL PARADE. On July 4, 1914, the town and all of its schoolchildren had a parade down Main Street and an all-day community party to celebrate the laying of the cornerstone for the new Benjamin Franklin Grammar School on East Ridge. The parade included decorated cars celebrating each of the states and territories, including Wyoming, shown here. In the background of this real-photo card is the Jesse Lee Methodist Church and Rectory.

THE NEW SCHOOL PARADE. The 1914 parade for the cornerstone laying at East Ridge included many town organizations. Here is the Ridgefield Grange and its elaborately decorated float, filled with produce and flowers grown by the grangers. In the left background is the Methodist rectory, and behind the marchers is the Telephone Building. Both buildings still exist.

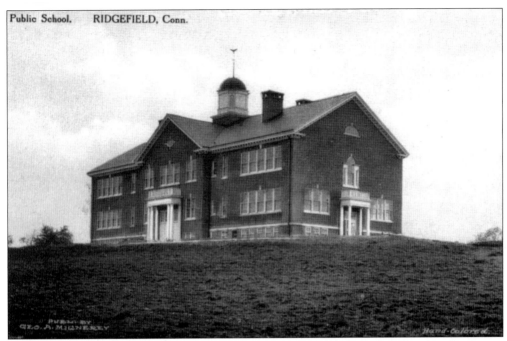

THE PUBLIC SCHOOL. These two views of the new Benjamin Franklin Grammar School were taken shortly after the building opened in 1915. The structure housed grammar school grades, including kindergarten. In 1927, the Alexander Hamilton High School on Bailey Avenue was moved to this building, and the school's name was changed to Ridgefield High School. The building itself, which also housed middle school grades, was called the East Ridge School. The note on the back of the top card, written in a child's script to a young Winifred Osborn, says: "Dear Winifred. I hope you will get better soon. I think I will have the mumps soon. Your loving chum, Dorcas Baker." Winifred Osborn grew up to be Winifred Carriere, an author of books on gardening and cats. One of her most widely quoted observations is "Cats always know whether people like or dislike them. They do not always care enough to do anything about it."

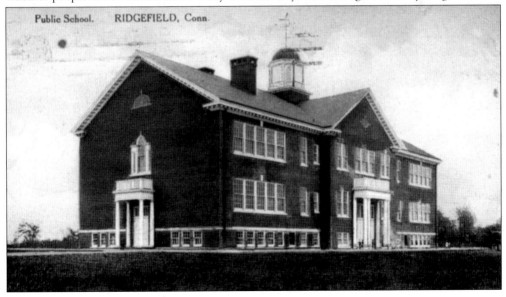

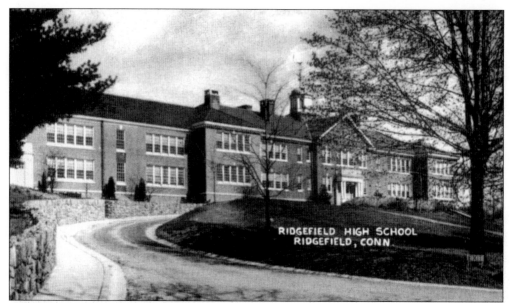

RIDGEFIELD HIGH SCHOOL. Much expanded with classrooms and an auditorium, Ridgefield High School looked like this by the late 1940s. The school closed in 1972, when the new high school opened on North Salem Road. For a while it was used as headquarters for Boehringer Ingelheim, the pharmaceutical company in Ridgebury; today, it holds the offices of the Visiting Nurse Association, the Ridgefield Board of Education, town land-use agencies, and a magazine publishing company. The auditorium is now the Ridgefield Playhouse for Movies and the Performing Arts.

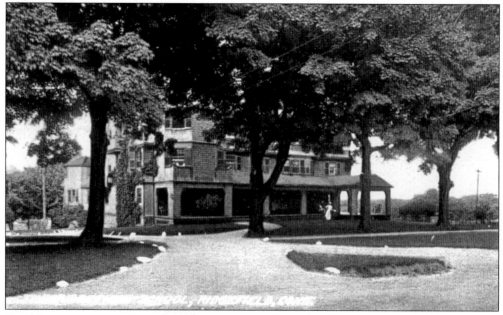

THE RIDGEFIELD SCHOOL. Several private schools operated in town during the early 20th century, the most famous of which was the Ridgefield School. Established in 1907, the boys' preparatory school was originally called the Mulford School after its founder and director, Dr. Roland Jessup Mulford.

94

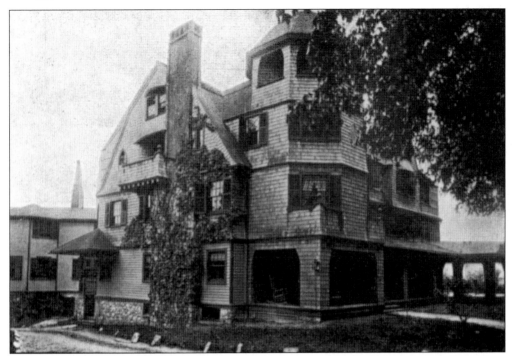

THE RIDGEFIELD SCHOOL. For its first four years, the Ridgefield School used the building that, during summer vacation months, was the Ridgefield Inn (see pages 9 and 66). The school became successful enough that bigger quarters were needed; in 1909, the operators bought the 115-acre Edmonds farm on the north end of Lake Mamanasco off North Salem Road for a new campus.

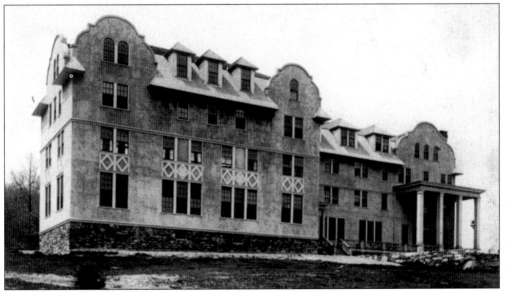

THE RIDGEFIELD SCHOOL. In 1911, the new Ridgefield School opened its doors. The four-story main building, shown here, was eventually expanded to include more than 100 rooms. Many of the Ridgefield School's graduates went on to work in the U.S. Foreign Service. One became governor of New Hampshire. The Great Depression eventually doomed the school, and it closed in 1938. A small portion of this building still stands today as part of a house.

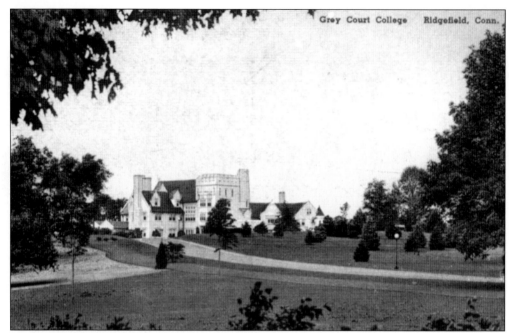

Grey Court College Ridgefield, Conn.

GREY COURT COLLEGE. Ridgefield, a college town? For a short while in the 1940s, it was. In 1941, Upagenstit, the 70-acre estate of Frederic E. Lewis, was acquired by Grey Court College (erroneously spelled Gray below), which had been in Stamford. In September the junior college for women opened with an enrollment of 70—one student per acre—and 14 faculty members. The top card was originally produced when the house was still a private residence. It was reissued with a new title when the college took over. The image below gives a rare view of the back of the huge manor house, complete with three coeds posing for the photographer. By 1946, Grey Court had vanished. (The author has never been able to find anyone who graduated from the school—or, at least, anyone who admitted it.)

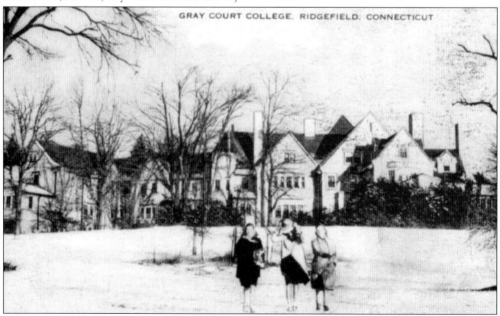

GRAY COURT COLLEGE. RIDGEFIELD. CONNECTICUT

Seven
HIGHWAYS AND BYWAYS

Roads were often prominent features of postcards, including many on earlier pages.
The following collection shows a variety of road-oriented scenes.

A SCENE ALONG THE DANBURY–RIDGEFIELD HIGHWAY. Swans ease their way across Outpost Pond in this scene from the 1930s. The stone bridge carries the old Danbury Road over the Ridgefield Brook—actually, the upper reaches of the Norwalk River—in front of what are now Fox Hill condominiums. For two centuries the main road through Fox Hill, east of the pond, was the old Danbury Road; the state put the straight road in, west of the pond, *c.* 1927. This bridge is on the old road at the south end of the pond. Beyond it are the waters of Great Swamp, the source of the Norwalk River.

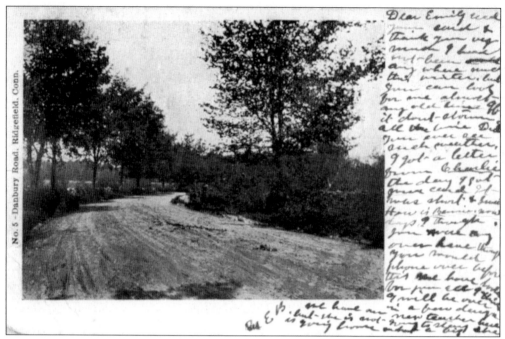

DANBURY ROAD. One of the oldest—and least attractive—Ridgefield postcards is this nondescript scene along Danbury Road, complete with a rich supply of horse droppings. Yet, many copies were sold. The example here demonstrates how the government required the messages on early postcards to be written on the front; the other side was to be used only for the address. The writer, E.B., was about as compact as one could be in fitting a message.

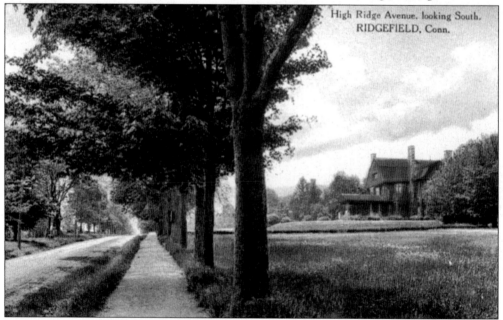

HIGH RIDGE AVENUE, LOOKING SOUTHWARD. In contrast to the previous image is a much more typical card, showing a view along High Ridge, just south of King Lane and Peaceable Street. The E.P. Dutton house (see page 50) is on the right.

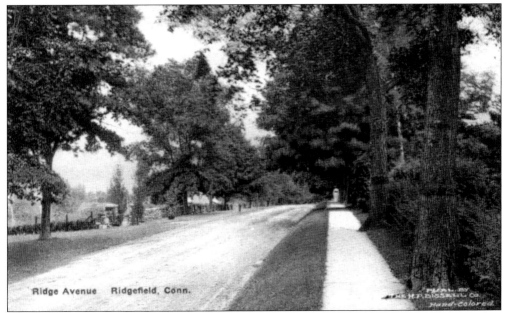

Ridge Avenue Ridgefield, Conn.

"RIDGE AVENUE." The card publisher Albertype labeled this view Ridge Avenue, but it is really High Ridge Avenue, or Road, a few hundred feet south of the picture on the previous page. Back in the late 1800s and early 1900s, the west side of the road was for mansions and the east side, visible at the left, was kept open to give the mansion owners a view across the village. Only one house and a couple of small outbuildings were found on the east side of the road back then.

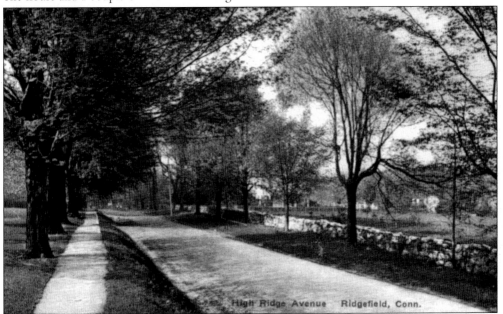

High Ridge Avenue Ridgefield, Conn.

HIGH RIDGE AVENUE. This viewpoint is south of the previous one, almost to Parley Lane, looking in the opposite direction. The scene is from the early 20th century and is similar to what is there today. The stone wall remains, but several houses are now visible. In the distance, barely visible in the center of the picture, is the only house on the east side of High Ridge Avenue—described in 1912 as belonging to a Mrs. Grey.

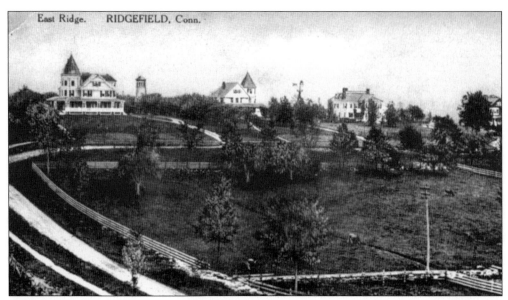

East Ridge. RIDGEFIELD, Conn.

EAST RIDGE. West of Main Street is High Ridge; east of it is East Ridge, which at the beginning of the 20th century, had only four houses, all shown here. At the left was a place built by the Rockwell family that, with the one next to it, became the Vinton School for Girls early in the 1900s. By the 1920s, the house was the barracks for State Police Troop A; since 1976, it has been the headquarters of the Ridgefield police. Visible out back is a water storage tower. The next house is a private residence, and the third is a house that has been owned by two Ridgefield first selectmen, completely unrelated. An old wind-operated water pump is seen between the second and third houses. The last house, at the extreme right and barely visible, was once the home of Maude Bouvier Davis, aunt of Jackie Bouvier Kennedy Onassis. The fields in the foreground, part of Gov. Phineas Lounsbury's Grovelawn estate (page 46), are now the playing fields at Veterans Park. Governor Street is at the lower left.

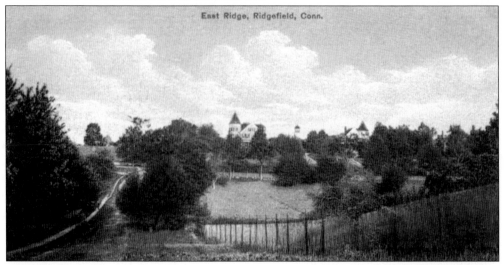

East Ridge, Ridgefield, Conn.

EAST RIDGE, 1910. This lush 1910 view of East Ridge shows the present-day police station and the house next to it. The card makes Governor Street look like a weed-filled path, while the sidewalk is clean and clear. It was just a coloring error by the German lithographers—the dirt road was well established by then.

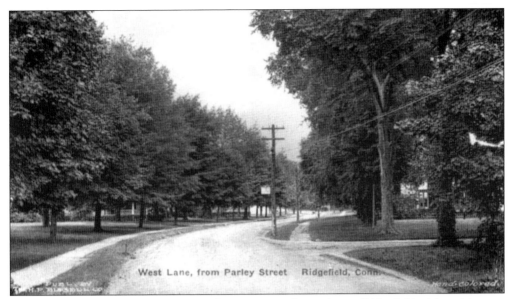

West Lane, from Parley Street Ridgefield, Conn.

WEST LANE, FROM PARLEY STREET. For many people coming to Ridgefield, either visitors or residents, the main entrance to the town was West Lane, serving people coming from the stations at Katonah, New Canaan, and Stamford, or anyone driving to town from New York. Consequently, many postcards depicted the road itself, as well as buildings along it. This view, from nearly in front of today's West Lane Inn, looks eastward toward Main Street and the fountain (not yet erected). The sign advertises the old West Lane Inn, later called the Bluebird Apartments (see page 76).

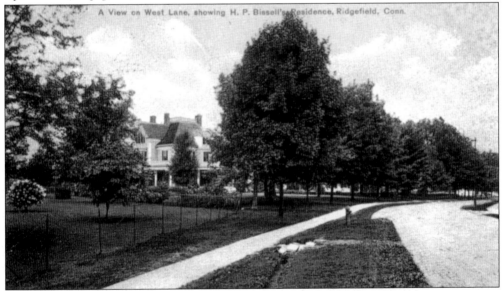

A View on West Lane, showing H. P. Bissell's Residence, Ridgefield, Conn.

A VIEW ON WEST LANE, SHOWING THE H.P. BISSELL RESIDENCE. This view, postmarked 1908, is closer to Parley Lane than the previous one is and shows pharmacist H.P. Bissell's house, now the West Lane Inn. Barely visible in the distance of both this and the preceding card are the porch columns of the old Corner Store at Main Street and West Lane. Both of these scenes are amazingly similar a century later—even the fire hydrant is still there, albeit in a more modern edition.

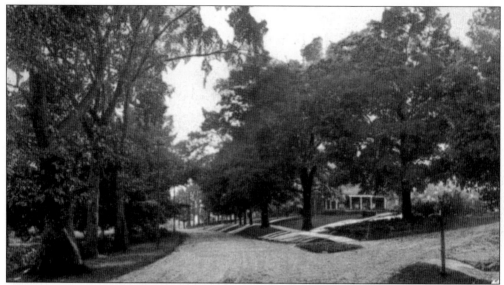

THE RESIDENCE OF DR. A.L. NORTHRUP, WEST LANE. Undoubtedly the photographer of the previous view simply turned his camera 180 degrees to get this westward shot of West Lane. Both cards were commissioned by Bissell and printed by Litho-Chrome in Germany *c.* 1907. The scene is a pretty one, especially in color, but hardly shows the Northrop house, still standing today. The property has an odd claim to fame—three presidential connections: Cyrus Northrop, born in a house that preceded this one, taught rhetoric to both Theodore Roosevelt and William Howard Taft at Yale and went on to become president of the University of Minnesota; Mrs. A.L. Northrop was the aunt of Pres. Warren G. Harding, who as a U.S. senator, once visited her here.

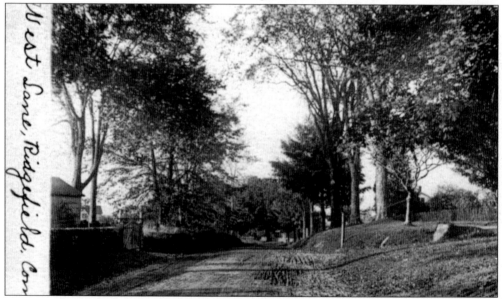

WEST LANE. About 200 feet west of the previous view is this scene at the intersection of West Lane and High Ridge; the beginning of High Ridge is at the right foreground. This real-photo print is one of the oldest Ridgefield postcards—it is a private mailing card from *c.* 1900. Several houses, barely visible in the picture, still stand today, and the overall view is much the same—except, of course, that pavement has covered the dirt.

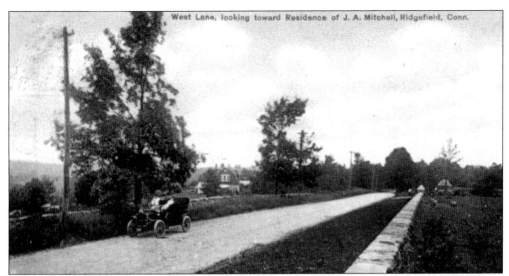

WEST LANE, LOOKING TOWARD THE J.A. MITCHELL RESIDENCE. Today, from the top of this stone wall in the summertime, it would be difficult to see J.A. Mitchell's house, although it is still standing (page 59). Little can now be seen except for trees, shrubs, pavement, and maybe cars. Few tall trees stood when this picture was taken *c.* 1907, reflecting the fact that all this land had been farmers' fields and pastures. The estate at the right, whose entrance gate appears in the distance, was the Dempsey-Farrar home (see page 60), which was brand new at the time. That fine old car in the road probably belonged to the photographer and held his family.

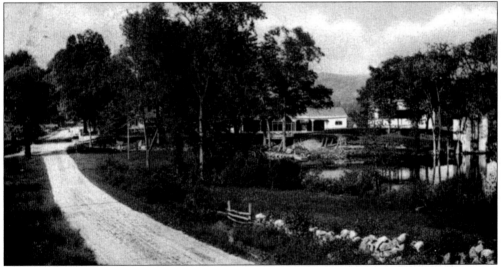

MAPLEWOOD HOTEL IN SUGAR HOLLOW, BETWEEN RIDGEFIELD AND DANBURY. This view shows territory entirely within Danbury, but the photographer was standing within a few feet of the Ridgefield town line. It is included to show how much Route 7 has changed in the past 100 years. The pond is still there and so are some of the outbuildings for the hotel complex, but most of the trees are gone and the dirt path to Danbury is now a wide and busy swath of pavement. The hotel property is now a collection of shops, a restaurant, and a nursery sales center. In the distance, Bennett's Farm Road heads off to the left toward Ridgefield and the old Fox Hill Inn. For a long time, Bennett's Farm Road was called Maplewood Road, after the hotel. This card was postmarked 1907 in Ridgefield.

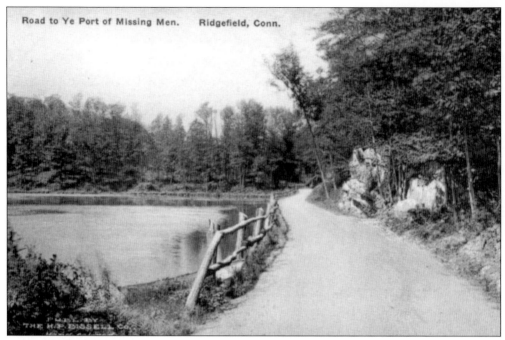

Road to Ye Port of Missing Men. Ridgefield, Conn.

ROAD TO YE PORT OF MISSING MEN. These two views of Old Sib Road were without doubt taken at the same time. The upper one looks toward the west, while the lower looks toward the east. Both show the road as it cuts by a stone outcropping and along Turtle Pond, also called Hidden Lake. Both the road and the pond were built *c.* 1905 by recent Italian immigrants, many of whom had come to Ridgefield to work on the new sewer and water lines at the turn of the century. More than 10 miles of road were constructed for the Port of Missing Men resort, which was a mile or so west of this point (see page 80). The land around most of Turtle Pond is open space, donated by the late Louise D. Peck, who also gave the community other land and bequests totaling several million dollars at her death in 1999.

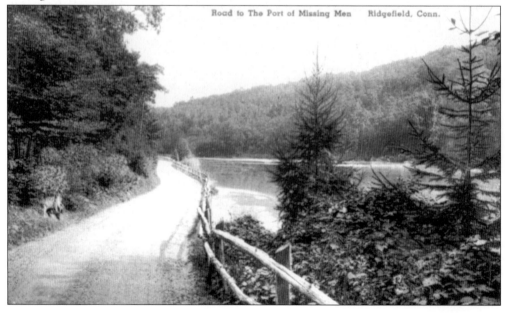

Road to The Port of Missing Men Ridgefield, Conn.

Eight

BRANCHVILLE:
THE OTHER VILLAGE

Branchville emerged in 1852 in the southeast corner of town;
it later grew to become Ridgefield's second village.

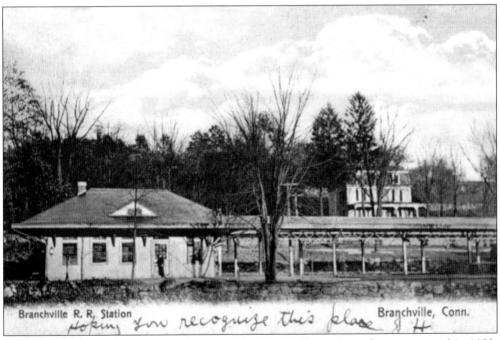

Branchville R. R. Station *Hoping you recognize this place* Branchville, Conn.

THE BRANCHVILLE RAILROAD STATION. The Branchville section of town emerged in 1852, when the Danbury and Norwalk Railroad line opened and a station was established in the southeast corner of town. Before that, the neighborhood had been quiet farmland, with some small mills along the Norwalk River. The railroad brought commerce and soon Ridgefield Station, also called Beers Station, became a small village with stores, a hotel, a post office, a school, and small industries, including a granite works and blacksmith shops. When the branch rail line opened from here to Ridgefield center in 1870, the station was renamed Branchville and so was the district. This view from *c.* 1905 shows someone who is probably the stationmaster at the door of the station. The house in the background, on West Branchville Road, is still there.

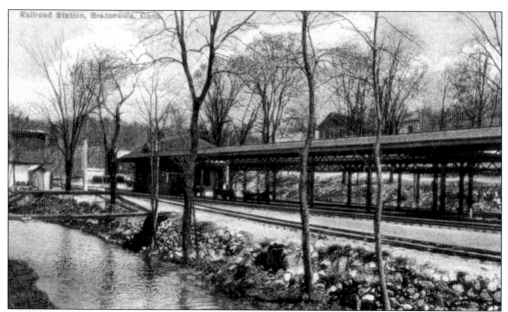

THE RAILROAD STATION, BRANCHVILLE. This view, postmarked 1910 and published by L.C. Mead's store in Branchville, shows the Branchville Station, looking northward. At the left is the water tower that supplied the steam engines, and directly in front of it is the pump house. The track in the foreground was a siding for freight car storage, which connected to the branch line to Ridgefield at a point just before the water tank. Its south end connected to the main line just south of Portland Avenue. Note the footbridge, also at the left, across the Norwalk River.

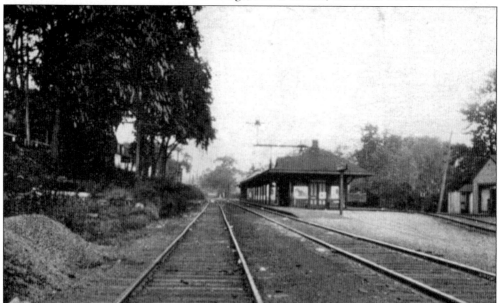

THE RAILROAD STATION, BRANCHVILLE. This view of the station looks southward. A small portion of the siding that connected to the Ridgefield branch line is at the right corner near the storage sheds and pump house; the actual branch line switch line is visible. Out of sight just to the right is the water tower. The left track on the main bed was a siding that allowed storage of freight cars or could hold a passenger train waiting for a train to pass from the opposite direction.

THE NORWALK RIVER, BRANCHVILLE. Mead's store published several other German-printed cards, probably all photographed at the same time. This one, looking southward along the Norwalk River, shows the edge of the station's small freight yard, with a portion of a coal car visible. The bridge in the distance carried Portland Avenue over the river, and a modern version is still there today. When this picture was taken, the main highway—now Route 7—was east of the train station (beyond the left side of this view; see page 108). Today, the highway is west of the river, to the right of the picture.

THE BRIDGE ACROSS THE NORWALK RIVER, BRANCHVILLE. The bridge in the previous card is shown from a different angle here. The photographer, who was facing eastward, would have been standing in the middle of what is now Route 7, a road that did not exist then. Crossing the bridge on Portland Avenue, one would have found the railroad yard on the left, and continuing, would have passed over three tracks, apparently eliminated from the image by touch-up work. Beyond the tracks was the Danbury and Norwalk Turnpike Road, the main north-south highway, which is visible here. Today, the section to the north (left) of the intersection is called West Branchville Road, and the section to the south, Portland Avenue. The road veering up the hill is today called Peaceable Street; the Redding town line is at the top of the hill. The building at the intersection was for many years the DeBenigno family's Branchville General Store, which catered to the sizable population of Italian immigrants in the neighborhood. The building, which is on the National Register of Historic Places, has been used as an art gallery in recent years.

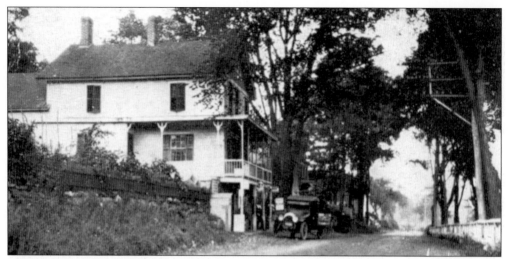

MAIN STREET, BRANCHVILLE. The business district of Branchville used to be on the east side of the railroad tracks, along what is now called West Branchville Road (an absurd name for the easternmost road in Branchville and in all of Ridgefield, for that matter). The view looks southward, and this building, an old grocery store, still stands today. In the 1920s and early 1930s, the store was operated by Walter M. Little, who despite his name, was "a big guy," recalled Dom D'Addario, who grew up a few doors away. The peak of this building is also visible in the card at the top of page 106. When Route 7 was built through Branchville in 1928, commerce on this road dried up and moved to the new main highway—see the next two cards.

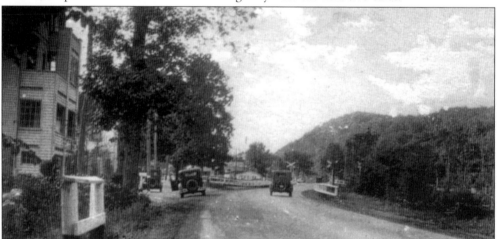

STATE ROAD, BRANCHVILLE. In 1928, the state paved the dirt road from Norwalk to Danbury with concrete. In the process it eliminated a number of curves and jogs along the way. In Branchville, the old road had crossed the tracks, run along the east side of the railroad station (as shown in the previous view), and then veered back across the tracks to follow the Norwalk River northward through the Cedar Mountain valley. By straightening the road, the state eliminated two crossings of the main train line, although the new road now had to cross the branch line to Ridgefield. This view, looking northward in the early 1930s, shows the branch line crossing in the distance, right at today's intersection of Routes 102 and 7. At the left is 33 Ethan Allen Highway, a building that today houses businesses, including Peter's Mane Concern. Note the two cars parked in the left center; they appear in the next postcard, viewed from the opposite direction. (Card loaned by Carol and Nano Ancona.)

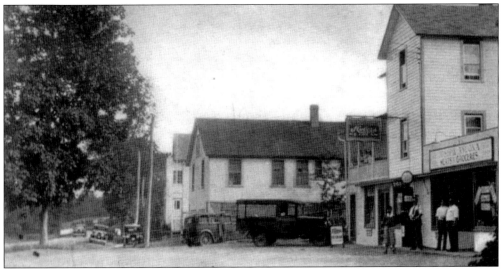

THE BUSINESS SECTION, BRANCHVILLE. "Joseph Ancona Meats and Groceries," says the sign on the store at the right, the forerunner of today's Ancona's Market, in this view looking southward along Route 7. The man standing on the right in front of the store is believed to be Joseph Ancona himself, a native of Italy who came to this country in 1912 and soon after established his store. Today, his children and grandchildren run the business, and Ancona's is the oldest continuously owned family business left in Ridgefield. Just to the right of this view, Joseph's brother, Frank Ancona, had a restaurant at this time. Beyond the Ancona delivery truck, a 1931 Chevrolet, is a building that today houses Amici's Restaurant and had earlier held Cooper Tavern, Luigi's, and Americo's restaurants. Note that back then, Ancona's sold gasoline. All the buildings in this picture still exist. Ancona's Market, however, is now in more modern quarters to the west of this building. (Card loaned by Carol and Nano Ancona.)

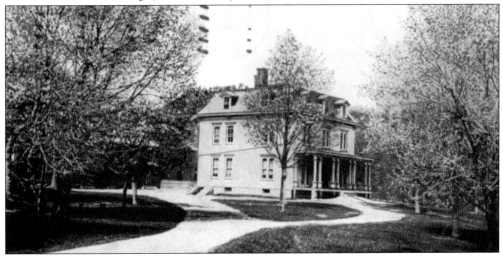

LIFE'S FARM, BRANCHVILLE. Life magazine publisher John Ames Mitchell, who lived on West Lane (page 59), joined Horace Greeley of the New York Herald-Tribune in creating the Fresh Air Fund, which established this camp in 1899 on lower Florida Road. Over many summers into the 1950s, thousands of children from New York City spent a couple of weeks in Branchville. The main building here housed staff and offices; the youngsters lived in a barracks, barely visible in this view, behind it.

THE SWIMMING POOL, CAMP HIDDEN VALLEY. By *c.* 1950, when this card was produced, the New York Herald-Tribune Fresh Air camp in Branchville was being called Camp Hidden Valley and included this nice big swimming pool. After the camp closed, the town bought the land and, in 1967, opened Branchville Elementary School on the property.

Nine
COMMERCIAL CARDS

The following is a sampling of old postcards used to promote businesses.

THE RIDGEFIELD BAKERY. In the days when bakeries brought their fresh goods to right to everyone's doorstep, Charles H. Stevens stood proudly alongside his delivery wagon for this real-photo card, mailed in 1911. The Ridgefield Bakery had been founded in 1866, and Stevens operated it during the first two decades of the 20th century; the storefront appears in the top card on page 32. In 1924, the Hurzeler family from Switzerland took over the bakery and ran it for the next 20 years. When Rudolph Hurzeler retired in 1944, he sold it to someone who abandoned the baking end of the business, preferring to buy his baked goods out of town for resale here. The bakery remained in business into the 1960s, always on Main Street. Although this is a real-photo card, someone hand-colored the truck and Stevens's tie red.

THE MIRACLE STUDIO. Back in the 1930s, the Miracle Studio published this elegantly drawn card to promote its weaving supply business. The building was on the west side of Route 7, north of New Road and south of Stonehenge Inn. This card is black and white, but colored versions also exist. The artist, named Elder, signed the pen-and-ink drawing at the lower right.

GAINES RESEARCH KENNELS. A close look at the back wall of the cocktail lounge in the postcard on page 73 reveals this identical picture. The photograph was probably taken when the building was the office of Outpost Nurseries, Col. Louis D. Conley's vast operation, and the postcard manufacturer simply altered the sign to reflect the new owner. According to the back of the card, "research studies in dog nutrition and genetics are carried on in this building and adjoining kennels." The building, still on Route 7, is used for offices at Stonehouse Common.

GAINES RESEARCH KENNELS. If this picture and the one below have vaguely familiar look, it is only because the building still stands along Route 7 just north of Route 35. Today, the longtime kennel is a fancy Italian restaurant: Belzoni's Red Lion. Col. Louis D. Conley of Outpost Farm and Nurseries built the kennel in the 1920s to house his dog-breeding operations. The 175-foot-long building was said to be the largest kennel in New England at the time. At one point, Conley had 20 Kerry blue terriers (his favorite), 19 Sealyham terriers, 40 cocker spaniels, and 60 English setters in the kennel. This view, taken when it still belonged to Gaines in the 1940s, shows "exercise courts for animals used in experimental work in the feeding, care and training of dogs."

WALDECK KENNELS. Before Gaines bought the building, Waldeck Kennels used the place in the late 1930s and early 1940s. According to a 1940 yellow pages advertisement placed by E.L. Winslow, president of Waldeck, the kennels bred St. Bernards and cocker spaniels and offered boarding, grooming, showing, and "dog furnishings." The building was converted to a steakhouse in the 1950s, the Red Lion Inn in the late 1960s, and Belzoni's some years later. Finch's Cigar Store on Main Street published this card.

THE BOOK BARN. One of the most popular destinations in Ridgefield in the 1930s was the Book Barn, a combination tea shop and bookstore on the east side of Wilton Road West (Route 33), right at the Wilton line. In a rhyming advertisement from the 1930s, owners Emmy and Fred Gregor described their place: "The Book Barn in Ridgefield is on Bald Hill. Here you'll find a well-worn sill. . . . Lift the barn latch and step inside, for this is where the books abide. If it's cold with winter snow, on the hearth the fire will glow, or from the city's summer heat, you will find a cool retreat. You'll enjoy the ingle nooks and the shelves with rows of books. Have some tea, forget your toils, the cheery singing kettle boils." The Book Barn is now a private home, but on the outside it still looks very much as it did in the 1930s.

JENSEN'S HILLTOP SERVICE STATION. From at least the early 1930s until *c.* 1967, a filling station was operated on Wilton Roads East and West (Route 33) a little north of the Wilton line, mostly by the Jensen family. As the back of this card from *c.* 1950 says, Hilltop was "a typical country service station" that offered gasoline, tires, and batteries, as well as some convenience items. Established long before zoning was adopted, Hilltop was the only commercial operation for miles in any direction. When Shell bought the place in 1968, this building was torn down and replaced with a modern gas station. However, the owner could not make a go of selling just gasoline and tried, unsuccessfully, to get zoning officials to allow a more profitable repair garage there. When that failed, the station went through ownership changes and closed, standing unused for many years—a commercial anomaly and eyesore amid miles of residential properties.

114

THE CIRCLE LUNCHEONETTE. In the 1940s and 1950s, the Circle Luncheonette was a popular spot for travelers. Situated on Route 7 just south of the Route 35 intersection, the restaurant was also just north of the town's only motel, the Green Doors. Alice Finch established the eatery and advertised with Spartan simplicity, "good food, quick service." After the luncheonette closed in the 1960s, the place became a printing shop. The interior of the Circle Luncheonette (below) reflected the knotty-pine craze of the mid-20th century. Walls, tables, and chairs were all made of pine. Note the pinball machine in the corner. The luncheonette got its name from the fact that until the 1970s, the intersection of Routes 7 and 35 was an old-fashioned traffic circle. Designed by Leo F. Carroll, a state police executive and later Ridgefield first selectman, the circle was sometimes called "Carroll's Folly," much to the man's chagrin. As traffic increased and state highway officials became less enchanted with traffic circles, the intersection was converted in the 1970s to a T design with traffic lights.

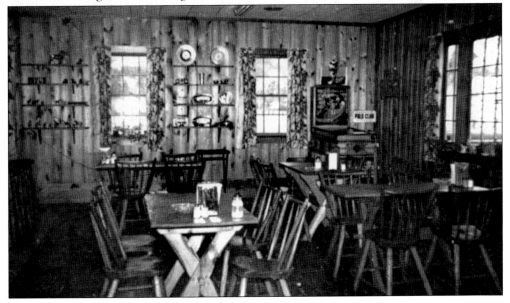

THE CIRCLE F RANCH. The early 1940s were not the best time to start a new business, especially a recreational enterprise. After all, World War II was raging. In 1942, however, someone opened the Circle F Ranch on the 300-acre grounds of Downesbury Manor, the former estate of hatting mogul Col. Edward M. Knox. This card, postmarked 1943, bears the message "Hi Folks. Feeling very frisky after a full day's activity and I don't mean sleepin'. See you later. Beth." The dude ranch was gone before the war ended. Edward Knox, who won the Congressional Medal of Honor for heroism at the Battle of Gettysburg, owned his 45-room mansion on Florida Hill Road at the turn of the century. It included a vast stable, an indoor riding ring, and miles of bridle trails. Here, Knox entertained his friend Mark Twain, who drove over or took the train from his home in Redding. Knox died in 1916, and Downesbury Manor went through various owners—it was a summer place for jeweler Pierre Cartier, a novitiate for the Holy Ghost Fathers, a hotel, and a sports club. Too big for any economical use, the house was finally torn down in 1958.

Ten
MISCELLANY

*Here is a hodgepodge of other postcards, including scenic views,
recreational pursuits, and some modest old houses.*

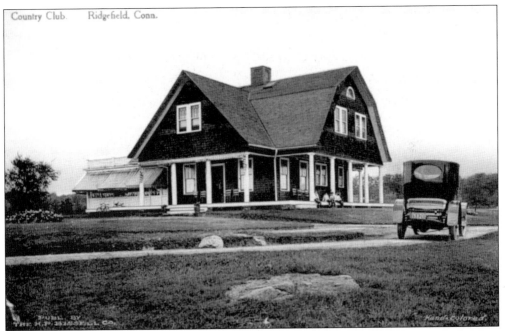

Country Club. Ridgefield, Conn.

THE COUNTRY CLUB. The Ridgefield Golf Club, built in 1894, established one of the nation's first courses, which covered 65 acres on Peaceable Street and Golf Lane. This was the clubhouse. Notice the boys on the porch, probably caddies (whose bicycles are over by the dining room at left). When Silver Spring Country Club opened in 1932, this course closed and later became a horse farm. Part of the course has been subdivided for houses. The clubhouse was moved in the 1930s to Grove Street, where it was a goat barn for a while and then a portion of the New England Institute for Medical Research. After the institute went bankrupt in 1982, the building caught fire and burned.

SILVER SPRING COUNTRY CLUB. Ridgefield's private golf club is shown, probably soon after it opened in 1932. The club was created by Ridgefielders who bought up several farms along the west side of Silver Spring Road to create a bigger and better course than the venerable Ridgefield Golf Club offered. This card was mailed in 1941, shortly before war rationing forced the club to shut down until 1946.

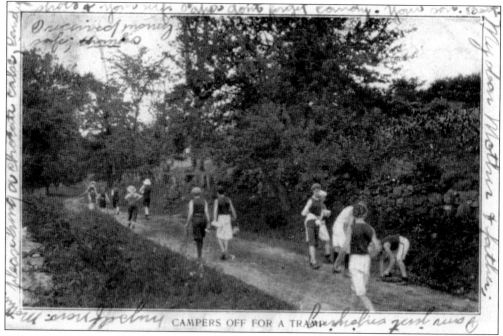

CAMPERS HEADING OFF FOR A TRAMP. This card poses a bit of a mystery. Postmarked from Ridgefield in 1906, the back says it is a "postcard of the Young Men's Christian Association." However, as far as is known, no YMCA camps were located here, although the Life Fresh Air Camp was operating then. The front of the card is filled with a note from a camper to his parents, Mr. and Mrs. A. Behning of New York City. "My dear mother and father, I am just enjoying myself now. Mother, please bring a cholate [*sic*] cake, candy, shoes and your self. Don't forget candy. Received money safely. Thanks. Your son, Burt." It sounds as if it could have been written last summer.

ARDEN CAMPS. Over the years several different summer camps operated on the north shore of Great Pond off Route 7, and Camp Arden was there in 1941, when this card was published. This was apparently one of a group of camps; another was on Lake Candlewood in New Fairfield, and others were in Vermont and Maine. The Volunteers of America later operated Camp Adventure there until *c.* 1970. Today, the old camp land along the shore has been preserved as open space and property to the north is the site of retirement housing and a nursing home.

THE FLOWER GARDEN OF MRS. GEORGE G. SHELTON, THE ORCHARD. Almost all of the fancy estates in town had equally fancy gardens, sometimes covering more than an acre. The gardens were not only beautiful but also kept the houses supplied with flowers. Gardens and greenhouses also provided employment opportunities for immigrants from Italy and Ireland, and many descendants of estate gardeners and groundskeepers are now prominent citizens of the town. The Shelton estate, called the Orchard, was on West Lane, literally straddling the state line. Dr. Shelton was the personal physician to Henry M. Flagler, the man who was largely responsible for developing the east coast of Florida early in the 20th century. Dr. Shelton was also a president of the Ridgefield Library. Mrs. Shelton was a founding member of the Ridgefield Garden Club.

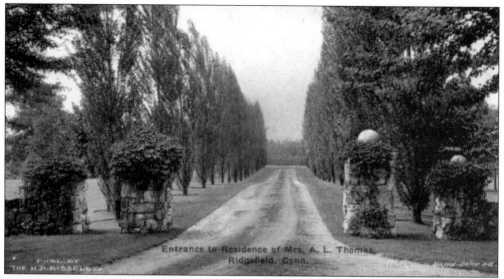

THE ENTRANCE TO THE RESIDENCE OF MRS. A.L. THOMAS. While gardens and grounds were important to the appearance of an estate, so was the entrance. Oddly enough, although copies of this card are fairly easy to find, no postcard image of the Thomas house itself has turned up. The brick mansion is still alive and well on Golf Lane—in this picture, it would have been off to the right. The entrance is also the same, but the slim, ornamental trees shown here bordering the driveway were long ago replaced with maples. A plaque out front says the estate is called Fair Fields.

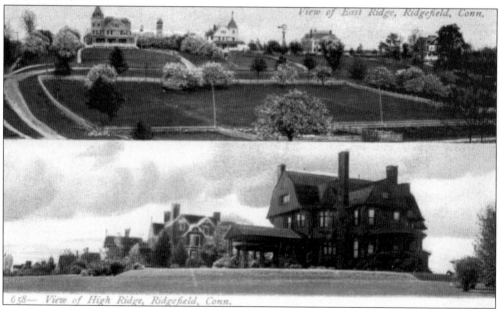

VIEW OF EAST RIDGE, VIEW OF HIGH RIDGE. This unusual German-printed card probably attracted bargain-hunters early in the 20th century. It combined images that were available on two individual cards; thus, in effect, you got two cards for the price of one. The upper view is East Ridge (see page 100), and the lower view is High Ridge (see pages 98 and 99). The house in the High Ridge foreground is the E.P. Dutton place (page 50). Beyond it is the Hamilton house (page 51) and Altnacraig (pages 51 and 52).

THE MEAL. This real-photo card, found in the papers of an old Ridgefield family, apparently shows some special event in town. Judging from the number of place settings, it must have been a huge gathering—perhaps the meal was held in connection with the big July 4, 1914 celebration of the building of the new school, about which a number of different real-photo cards were created (see page 92). Notice that both the seat supports and the flower vases are creatively concocted from box-shaped building blocks. Perhaps they had a symbolic connection with the new school's construction.

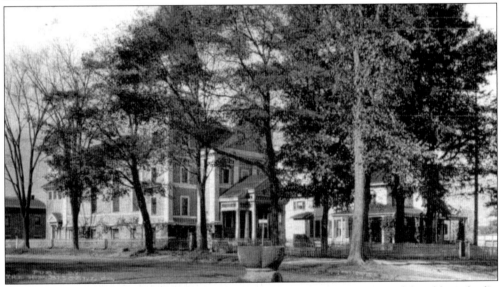

THE METHODIST EPISCOPAL CHURCH AND RECTORY. Several pictures of the old Methodist church at Main and Catoonah Streets appear on pages 86 and 87. This one from *c.* 1920, however, offers a view of a secular, not religious feature of old Ridgefield: the watering trough. The stone trough (lower center) was donated *c.* 1915 by John Ames Mitchell (see page 59); it even included a special opening for village dogs and cats, visible at the right bottom (village children also made use of it, Karl S. Nash reported—probably from personal experience). Troughs, usually made of wood or metal, were placed in various locations around town to slake the thirst of hard-working horses. When automotive means displaced equine transportation, this trough was moved to Titicus crossroads on North Salem Road and then finally to the triangle at West and Olmstead Lanes, where it sits today—serving as a giant flower pot during the summer, thanks to garden club members. Pictured at the far left is the firehouse.

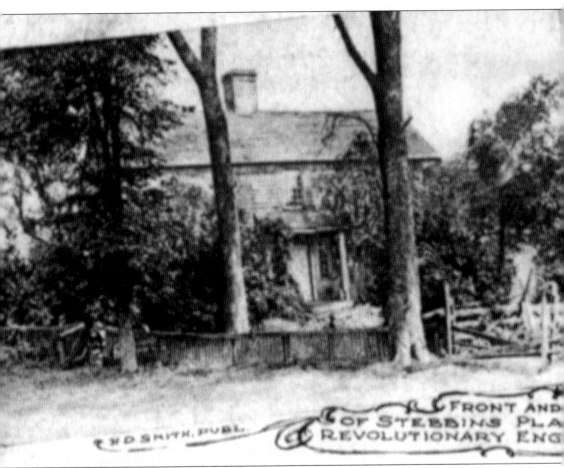

FRONT AND
OF STEBBINS PLA
REVOLUTIONARY ENG

P. HD SMITH, PUBL.

THE STEBBINS HOUSE. Although this card is an early one, dating from *c.* 1905, it shows a house that disappeared before picture postcards were invented. Published by pharmacist H.D. Smith in both color and black-and-white versions, the card shows two views of the 1727 saltbox of the Stebbins family, razed in 1892 to make way for Casagmo (the view on page 18 shows the Stebbins house in relation to Main Street; the view on page 43 shows the mansion in its place). Today, the Stebbins house would be a revered American monument, for it overlooked the Battle of Ridgefield in 1777, served as a hospital for the wounded, and was itself riddled with bullets during the skirmish. In the century that followed the Revolution, many visitors called at the

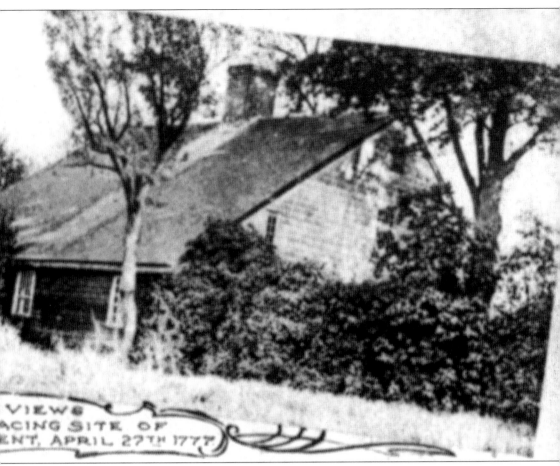

VIEWS
ACING SITE OF
ENT, APRIL 27TH 1777

house to see the bullet holes and the bloodstained floors in the parlor where Anna Stebbins, daughter of the owner, had tended to the wounded during and after the fight. Revolutionary and British soldiers who died in the battle were buried on the Stebbins land, a fact commemorated today in a tablet in the wall at Casagmo (see page 19). Gen. Benedict Arnold, a hero at the battle, had his horse shot from under him in front of this house and reportedly escaped via a cow path through the Stebbins property. The house is said to have escaped being burned by the British because one of the Stebbins sons, Josiah, was a Tory who guided the Redcoats as they marched from Danbury through Ridgefield.

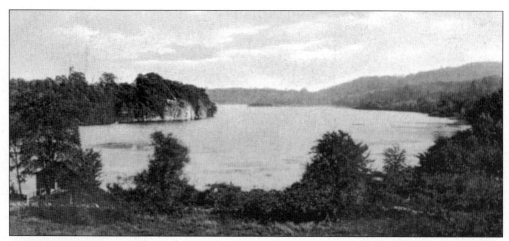

LAKE MAMANASCO. Ridgefield's largest body of water, a mile long and 96 acres in size, is pictured from the north end, looking southward in this German-printed card, postmarked in 1913. When this picture was taken, the property in the foreground probably belonged to the Ridgefield School (page 95), and the boathouse barely visible along the shore at the left may have served students and faculty. *Mamanasco* is a Mahican word that some have translated as "grassy pond" and others as "two ponds with a single outlet." Lake Mamanasco, dammed by the settlers in 1716, is the remnant of a large lake that covered the Titicus River valley after the last glacier receded 20,000 years ago. Throughout the 18th and 19th centuries, its waters powered a number of mills near its outlet. Archaeological evidence indicates that American Indians had camps or villages at the south end of the lake (in the distance).

LAKE MAMANASCO. This view looks northeastward from the west side of the lake, probably up on Old Sib Road. For generations of teenagers, the high, solid-rock cliffs visible here were considered a feat of bravado to leap from. There was even a legend that circulated among the town's youngsters that metal poles from stolen traffic signs had been thrown into the water and stuck up below the water's surface, "waiting to impale any jumper who hit a wrong spot," recalled Ridgefield Press editor Macklin Reid. "Bull, no doubt, since it would be very hard to get the sign poles to stick up, but a great kid scare story." Barely visible just above the rocks and a little inland is the mansion at Mamanasco Farm, the estate of Anne S. Richardson, who bequeathed 30 acres of her homestead to the town and at the same time ordered the house torn down. The lakeside land is now Richardson Park. Ridgefield High School is built on part of the Richardson farmland on the other side of North Salem Road.

THE HERMITAGE AND THE HERMIT, GEORGE WASHINGTON GILBERT. Last, but hardly least, is one of the most popular postcards ever published in Ridgefield—for obvious reasons. The striking picture entertained both senders and recipients. On the back of this copy, the sender writes: "Isn't this a charming little home? Ridgefield, Conn., is noted for its beautiful houses. This is no joke. It is, really. Fortunately, though, all the residents haven't the same keen and overwhelming sense of beauty that George Washington Gilbert has—or had. This is the life! Hey?" Born in 1847, Gilbert was an eccentric who literally allowed his family homestead on Florida Hill Road to fall down around him. He was not a recluse, however, and enjoyed visits from townspeople. He would entertain them, telling them old-time tales and showing them artifacts of the past such as the sword his grandfather had captured from a Hessian at the Battle of Monmouth. He also liked to pose mathematical puzzles such as "What is a third and a half of a third of ten?" Col. Edward M. Knox (page 116), whose mansion was nearby, took pity on him and built him a cottage. Gilbert was found there, frozen to death, on January 6, 1924. He is buried in Florida Cemetery on Route 7 under a stone that reads, "The Hermit of Ridgefield."

Bibliography

Bedini, Silvio A. *Ridgefield in Review*, Ridgefield, Connecticut: Ridgefield 250th Anniversary Committee Inc., 1958.

Bollenback, Dirk F. *St. Stephen's Church Reaches the Millennium: The Last 25 Years*, Ridgefield, Connecticut: St. Stephen's Church, 2000.

Corbin, Madeleine. *About Ridgefield: What We Were, Where We Are*, Ridgefield, Connecticut: Ridgefield Design Council, 2002.

Goodrich, Samuel G. *Recollections of a Lifetime*, 2 vols., New York: Miller, Orton and Mulligan, 1857.

Haight, Robert F. *St. Stephen's Church: Its History for 250 Years, 1725 to 1975*, Ridgefield, Connecticut: Vestry of St. Stephen's Church, 1975.

Nash, Karl S., et al. *The Centenary*, 100th-Anniversary Special Supplement Series of the *Ridgefield Press*, Ridgefield, Connecticut: Acorn Press Inc., 1975.

———. *Diamond Jubilee*, 75th-Anniversary Special Supplement Series of the *Ridgefield Press*, Ridgefield, Connecticut: Acorn Press Inc., 1950.

Ridgefield Archives Committee. *Images of America: Ridgefield*, Charleston, South Carolina: Arcadia Publishing, 1999.

Rockwell, George L. *The History of Ridgefield, Connecticut*, Ridgefield, Connecticut: the author, 1927.

Sanders, Jack. *Five Village Walks*, Ridgefield, Connecticut: Ridgefield Archives Committee, 2000.

———. *Notable Ridgefielders: A Who's Who of People Who Made News in the 20th Century*, Ridgefield, Connecticut: Hersam-Acorn Newspapers, 2000.

———. *Ridgefield Names: Articles Published in The Ridgefield Press from November 1976 to May 1984*, Ridgefield Press, Ridgefield, Connecticut: compiled and indexed by Ridgefield Archives Committee, no date.

Teller, Daniel W., *The History of Ridgefield, Connecticut*, Danbury, Connecticut: T. Donovan, 1878.

Venus, Richard E., *Dick's Dispatch*, 366 columns in the *Ridgefield Press* between 1982 and 1989, Ridgefield, Connecticut: compiled and indexed by Ridgefield Archives Committee, 1997.

Index